IMAGES
of America

DUARTE

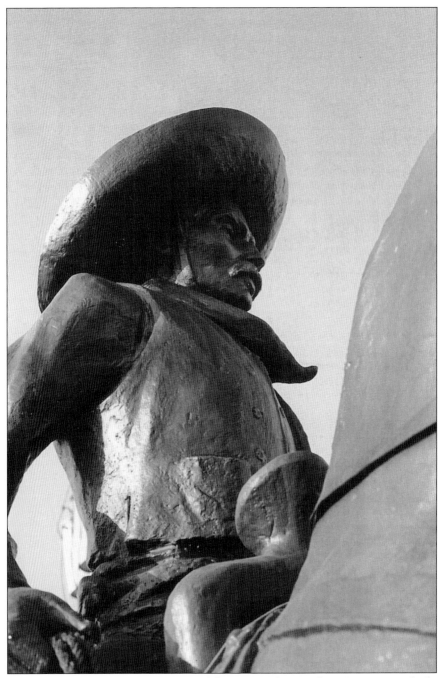

The monumental bronze equestrian statue celebrating Andres Avelino Duarte is in the business and governmental center of the City of Duarte. (Courtesy Irwin B. Margiloff.)

ON THE COVER: General store, post office, community center, dance hall, telephone outpost, even laundry pickup station, the Duarte Market was all things to all people for years, beginning before 1900. Joe Fowler, the proprietor, stands in the doorway. (Courtesy Duarte Historical Museum collection.)

IMAGES
of America

DUARTE

Irwin Margiloff, Neil Earle, and
the Duarte Historical Society

ARCADIA
PUBLISHING

Copyright © 2009 by Irwin Margiloff, Neil Earle, and the Duarte Historical Society
ISBN 978-0-7385-6911-6

Published by Arcadia Publishing
Charleston SC, Chicago IL, Portsmouth NH, San Francisco CA

Printed in the United States of America

Library of Congress Control Number: 2008942870

For all general information contact Arcadia Publishing at:
Telephone 843-853-2070
Fax 843-853-0044
E-mail sales@arcadiapublishing.com
For customer service and orders:
Toll-Free 1-888-313-2665

Visit us on the Internet at www.arcadiapublishing.com

CONTENTS

ACKNOWLEDGMENTS

When not otherwise indicated, the photographs in this book are from the extensive archives of the Duarte Historical Museum. The most generous contributors to the museum's collections over more than four decades have been the Duarte-Monrovia Fruit Exchange, Lucille P. Morrison, and Margaret Scott Meier. But there have been many others. We found that the 1976 work *On the Duarte* by Aloysia Moore and Bernice Watson was an invaluable source of oral history, including some interviews with people close to the original events. We have received many personal contributions and much assistance for this book from interested people, beginning with Alan Heller, community activist and chairman of DCTV, who first proposed the project.

Duarte city publicist Mary Barrow was a bulwark in helping arrange contacts and also sharing her extensive file of images. Levon Yotnakhparian, community volunteer and professional photographer, generously gave of his time to locate specific shots. Claudia Heller, president of the Duarte Historical Society, was always willing to write selected captions and help where necessary. Jim Kirchner of the Duarte Chamber of Commerce and Becky Evans at Duarte City Hall both granted access to caches of pictures at important junctures in the book's process. In a variety of ways, this book owes a debt of gratitude to the family of Andres Duarte.

Other individuals we need to thank include Kim Anderson, Stephen R. Baker, Sister Carmelina (OCD), Ruth Crist, Douglas Edwards, William Frank, Sidney K. Gally, Donna Georgino, Tina Heany, Karen Herrera, Courtney Justice, Stephen D. Miller, Jerry Nieblas, John Patten, Lois Spielman, Phyllis Ramos, Sandy Shannon, Kathy Treggs, Ana Maria Whitaker, Misi Ward, Cecilia Wictor, and Susan D. Yates. Neil would also like to thank his wife, Susan, who was always willing to help with scanning as well as sharing her unfailing good judgment in the selection process.

Organizations helping us include Bureau of Land Management/California, City of Duarte, City of Hope, Duarte Chamber of Commerce, First Baptist Church of Duarte, Huntington Library, Los Angeles County Registrar/Recorder, Mission San Juan Capistrano, Royal Oaks Manor, San Dimas Railway Museum, Santa Teresita Medical Center, and Westminster Gardens.

In a close-knit community such as Duarte, some people may wonder why certain things were left out and others were emphasized. The authors take responsibility for these choices while we also feel that herein is a valuable record for future efforts at telling the Duarte story.

—Irwin Margiloff and Neil Earle

INTRODUCTION

On March 31, 2007, to begin the city of Duarte's 50th anniversary of incorporation, an equestrian statue was dedicated to Andres Avelino Duarte on Huntington Drive. Andres Duarte was a former corporal in the Mexican army who received a grant of 6,595 acres from Mexican governor Juan Bautista Alvarado on May 10, 1841.

Enduring links with the past are one reason Duarteans feel their city of 21,486 people, occupying 6.8 square miles along the base of the San Gabriel Mountains, is distinctive. Duarte has a clearly documented beginning in time and space. Andres Duarte worked to secure his property after the Mexican War of 1846–1848. The rancho's enviable location attracted eager settlers and investors. In 1861, Dr. Nehemiah Beardslee arrived in an ox-drawn covered wagon from Texas. He brought with him seeds, young fruit trees, and Indian workers. The rancho was divided into 40-acre plots in 1872. With local help, the rancho became prime fruit-growing territory. It also became a magnet for people fighting the dreaded scourge of tuberculosis.

Along the way, education emerged as a priority. Our most distinctive building is a 1909 school building still in use. In 2008, students from Duarte High School (DHS) won both the State and National Academic Decathlons for their division. This continuity with its history is reinforced by the fact that descendants of Andres Duarte are often guests at local city events.

THE QUEEN COLONY

Families trickling in from the East and the Midwest shaped the emerging settlement. An eastern financier named Alexander Weil bought most of the rancho and ordered the first survey of the almost frost-free Upper Duarte (north of the present Huntington Drive). In 1883, an engineer from Maine named Lewis Leonard Bradbury purchased the western third of the original Andres Duarte holdings. This became the nucleus for the adjacent city of Bradbury in 1957.

Doctors, clergy, entrepreneurs, and scores of African American families moved in to lay the foundation for both citrus and open field production. Unique connections developed. Some black families settled on the Davis Addition or "Rocktown" and learned to speak Spanish like natives.

Water was of primary importance. Two of Duarte's first civic enterprises were the Beardslee Water Ditch Company (1881) and the Duarte Mutual Water Company (1884). The Duarte-Monrovia Fruit Exchange began early. Duarte's first store and post office was at the corner of Royal Oaks Drive and Highland Avenue—rebuilt in the 1930s and still used as a retail store, an early photograph of which graces our cover.

The uphill third of the old rancho, nestled against the virtually frost-free foothills, was prime citrus fruit land. Duarte oranges took first place at the 1890 State Citrus Fair, earning us the title "the Queen Colony." Canadian emigrant John Scott was named horticultural commissioner of Los Angeles County soon after his arrival in 1883. His skill at laying out orchards of prunes, peaches, apricots, and plums as well as olives was remarkable.

Next to water, railways were vital for Duarte's success as fruit producer and shipper. The Atchison, Topeka, and Santa Fe ran south of the city while the Southern Pacific ran north. The Pacific Electric's (PE) interurban distinctive big "Red Cars" were in operation by 1908. The PE also built the 1,019-foot-long reinforced-concrete Puente Aero Largo Bridge across the San Gabriel River between 1906 and 1907, an engineering marvel for the time.

Several piers of the Puente Largo succumbed to the great flood of 1938, yet a single track line kept running until 1951. The Oak Avenue Bridge, built to permit access to the Bradbury property, remains. The PE route was converted into a recreational trail in 1975.

In 1913, the National Jewish Consumptive Relief Association started a tuberculosis sanatorium on 40 acres south of what is now Duarte Road. The goal was to provide relief for overcrowded workers laboring in the Los Angeles garment industry. After 1946, this original plant grew steadily into the world-class City of Hope Medical Center, a recognized leader in fighting cancer and other catastrophic diseases.

In June 1927, three sisters of the Carmelite order, fleeing persecution from secular authorities in Mexico, were helping Spanish-speaking victims of TB in the Long Beach area. In 1930, dedicated Carmelite Nursing Sisters under Mother Margarita Maria purchased 3 acres in Duarte to found what became in 1956 Santa Teresita Hospital. Duarte's reputation as "the City of Health" was taking shape.

REINVENTING ITSELF

The automobile had impacted Duarte when Huntington Drive was cut through in 1925. In 1926, Congress ordered the construction of U.S. Route 66. Garages, motor hotels, service centers, and other new businesses sprang up along Huntington, including the fondly remembered juice stands. Dried figs for purchase, grown largely by resourceful Japanese truck farmers, testified to Duarte agricultural diversity. Duarte's connection with Route 66 is commemorated every September with a parade, picnic, and car display.

The Great Depression hit California hard. Duarte growers were already reeling from the expansion of Florida's citrus industry in the 1920s. Land prices collapsed, tracts were either sold off to speculators or targeted for annexation by neighboring cities. The late 1940s would see hundreds of GI tract homes springing up to replace the city's lush citrus groves. The population soared from 3,500 to 10,500 by 1948. The Queen Colony was reinventing itself.

Young families lobbied for new streets and public services, and between 1940 and 1950, five new schools were built. On August 22, 1957, the city formally incorporated. Walter C. Hendrix became the first mayor. Community activism kept pace with steady growth. The Literary Society dated to 1884. The Duarte 4-H Club was the oldest in Southern California. The Duarte Reading Circle, begun in 1909, helped organize the Duarte Chamber of Commerce in 1921, led campaigns to beautify state highways, aided children of unwed mothers, and lobbied to keep gambling and hog ranching out of Duarte. City benefactor Lucile Morrison and scholar Ida May Shrode organized the Duarte Historical Society in 1951. The Friends of the Duarte Library, first organized in 1961, launched the annual Duarte Festival of Authors in 2002.

Between 1975 and 1985, some 2,000 new homes were built. Population exceeded 20,000 by the 1990s, and voluntarism continued to flourish. Duarte Rotary's 1977 admission of three women, a groundbreaking initiative, was upheld by decision of the U.S. Supreme Court on May 4, 1987. In 2006, pop singer Olivia Newton-John helped kick off the City of Hope's annual March for Hope.

QUIETLY PROGRESSIVE

In 1971, Duarte elected Donald R. Watson as the San Gabriel Valley's first black mayor, highlighting the city's early ethnic diversity even as freeway construction in the late 1950s brought an end to Rocktown in 1968.

This, then, is Duarte, a community where quality of life issues loom large and where civic leaders are inspired by the rich pageant of the past. At the Andres Duarte statue dedication in 2007, it was noted that Victoria Duarte Cordova, a great-great-granddaughter of Andres and Gertrudis Duarte, had passed away in 2005, but other family members remain. With clearly identifiable links to its founding, Duarte remains a city in continuity with its best traditions of culture and community.

One

SPANNING TWO ERAS

In June 1841, an imaginary helicopter news team flying over the winding San Gabriel River that issues from the scenic mountain range to the north would see a small group of men—two of them with sticks—measuring out a one-league square. Among them was citizen Andres Duarte, a former corporal in the Mexican army. There were also public officials from the pueblo of Los Angeles and others representing the neighboring ranchos of Santa Anita and Azusa de Arenas, checking on the precision of the measurements.

With these activities, the Duarte rancho was born. Two years later, Don Andres Duarte filed his own distinctive cattle brand with the local registry. A small portion of the first Duarte adobe still stands, although it is incorporated into a late-Victorian frame house at the end of Tocino Drive.

On December 15, 1855, Andres and Gertrudis Duarte made their marks on the area's second land transaction—100 acres to Michael Whistler for $200. The original Duarte land grant became caught up in the politics of land ownership following the Mexican-American War (1846–1848) and statehood for California. Geography precedes history, and while geography is not always destiny, the gently sloping land on which the rancho was sited catches the beneficent last rays of the afternoon sun. This made North Duarte a virtually frost-free zone, ideal for growing fruit.

This fact was not lost on the Beardslee, Maxwell, and Maddock families, whose early settlement on the original Rancho Azusa de Duarte ensured that a prosperous community would develop. A surprising number of these first immigrants from east of California were professional people—doctors, entrepreneurs, and even trained agriculturalists. The stage was set for stable and productive enterprise even as Andres Duarte found it impossible to retire his mortgage, eventually losing the rancho in 1862. Yet the son and grandsons of Andres and Gertrudis Duarte lived on, leaving a permanent imprint on the land. This chapter tells that story.

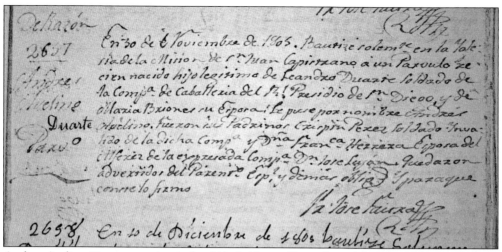

Andres Avelino Duarte was the sixth of 11 children of Leandro, a Mexican soldier, and Maria Briones Duarte. Book 1 of Mission San Juan Capistrano's baptism records shows Andres's baptism on November 30, 1805. At 16, Andres, like his father, became a soldier. As Major Domo at Mission San Gabriel, he monitored the mission's lands. He developed affection for the lands adjacent to the San Gabriel River (then the "Azusa"). (Courtesy Mission San Juan Capistrano.)

Andres and Gertrudis Duarte had one child, Felipe Santiago Duarte. He was born in 1828 and died in 1863, the same year as his father. All descendants of the Duartes of the land grant are descended from Felipe. This is the only picture that purports to show Felipe. There are no known pictures of Andres Duarte.

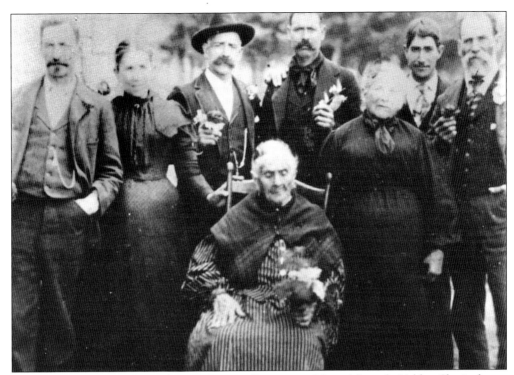

The last child of Leandro and Maria Briones Duarte was Maria Manuela Valdez. She is shown here late in life with several of her sons and their wives.

At 36, honorably discharged and having accumulated 300 or 400 head of cattle and horses, Andres Duarte requested a grant of part of the Rancho Azusa. His petition to Gov. Juan B. Alvarado in Monterey was written by his friend Castillo "on behalf of Andres Duarte, who cannot read." Each petition required a sketch, or diseño, to show what was being requested. This is Duarte's diseño. The land actually granted was to the west of the San Gabriel (then called the Azusa) River.

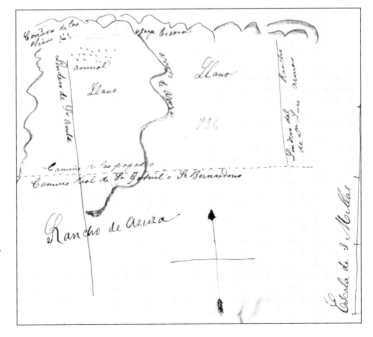

No interferences appear in the Pre-
mption Division.

G. A.K. Dickels

May 13. 1878

Approved

A notice of the approval of this plat of survey has
been published in accordance with the Act of Congress
of June 14th 1860 in the Los Angeles Star, the first pub-
lication thereof being on the 25th of August, 1860, and the
last on the 15th of September 1860; also in the paper nearest
the land being the San Bernardino Herald the first
publication thereof being on the 30th of August 1860
and the last on the 4th of October 1860

This plat has remained in this Office, subject to
inspection, from the date of the approval thereof
J.W. Mandeville

A full true and correct copy of the original plat
on file in this Office.
U.S. Surveyor General's Office.
San Francisco California.
March 23d. 1876

H.G. Collins

U.S. Surv. Gen. Cal.

AZUSA MO

SANTA ANITA RANCHO

Place of Beginning

Plain

T.1.N. R.XI.W.

Lot No 39.

T.1.N. R.X.W.

Lot No 37.

Sec.34 Sec.35 Sec.36 Sec.31 Sec.32

Sec.3 Sec.2 Sec.1 Sec.6 Sec.5

T.1.S. R.XI.W. T.1.S. R.X.W.

Lot No 44. Lot No 39.

SAN FRANCISCITA RANCHO

PUBLIC LAND

The field notes of "Azusa Rancho" confirmed to Andreas Duarte, and from which this
plat has been made out, have been examined and approved, and are on file in this Office
U.S. Surveyor General's Office
San Francisco California
January 4th 1860

I hereby certify
advertised in the
weeks, the date
published in the
the 14 of October
from the date of
U.S. Surveyor G
San Francisco C
January 14th 1

J.W. Mandeville
U.S. Surveyor Gen. for Cal.

12

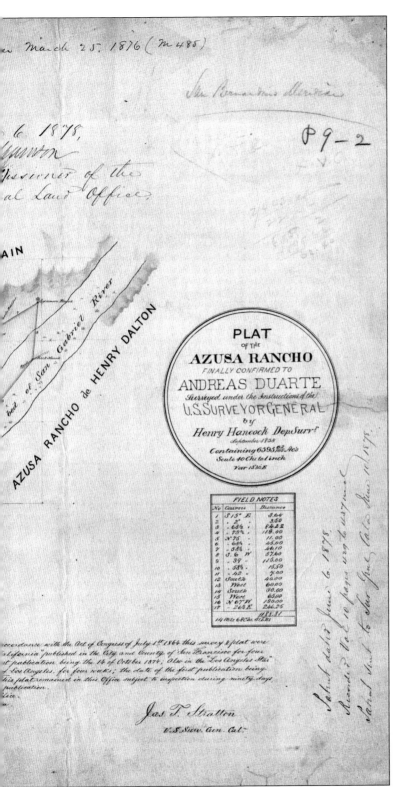

PLAT
OF THE
AZUSA RANCHO
FINALLY CONFIRMED TO
ANDREAS DUARTE
Surveyed under the Instructions of the
U.S. SURVEYOR GENERAL
by
Henry Hancock Dep Surr⁴
September 1858
Containing 6595.²⁰⁄₁₀₀ Ac's
Scale 40 Chs to 1 inch
Var 15 30 E

Statehood in 1850 led to a federal review of California's Mexican and Spanish land grants. They were classified as "Private Land Claims." During the Fillmore administration, formal proceedings before a Board of Land Commissioners determined which were valid. Upon hearing testimony and examining documents, the commission validated Duarte's claim and about two-thirds of all claims. Patents were issued to quiet title—to supersede all prior claims to the property. Grants found invalid became federal property. Henry Hancock, a surveyor and lawyer, mapped the rancho in September 1858, showing the Duarte claim as finally allowed, containing 6,595.20 acres, more than 10 square miles. Further legal proceedings, however, delayed the "final" patent issuance until 1878. By that time, many claimants, including Andres Duarte, had already died. This is a copy of the original map that is in the National Archives.

13

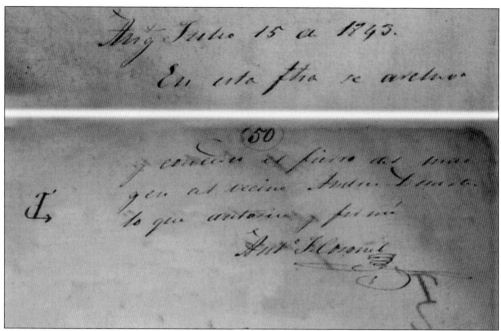

On July 15, 1843, two years after receiving the grant, Andres Duarte filed his own cattle brand in the local register of brands and earmarks. His stylized lower-case "d" was finished with a tilde for the upper serif and a long arrow for the lower. Shown here are parts of pages 49 and 50 of the register. Antonio F. Coronel signed the entry as the public official maintaining the register in that period. (Courtesy Seaver Collection, Los Angeles County Museum of Natural History.)

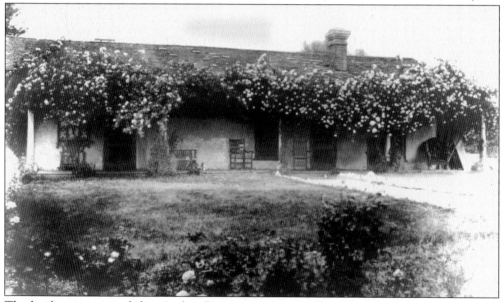

The land grant required that Andres Duarte construct and occupy a dwelling, a requirement similar to provisions of the Homestead Act of 1862. Duarte's adobe, a series of rooms in a single line, was built in the northeastern sector of the rancho as shown on the Hancock map. It was occupied by several families until, early in the 1900s, when owned by the Bacon family, a small part of it was incorporated into a late-Victorian frame house that stands on Tocino Drive.

Andres and Gertrudis had only one child, Felipe Santiago. Felipe had four children, one of whom was Jose Andronico Duarte, shown here, who in turn had four sons and two daughters.

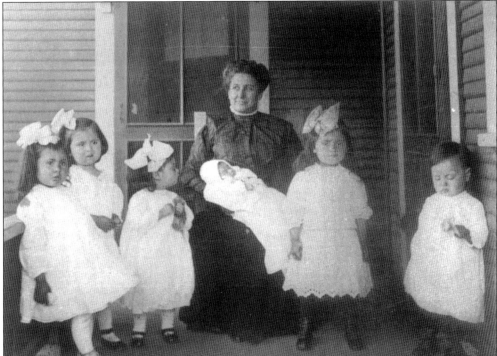

Maria Inocencia Yorba married Jose Andronico Duarte. She is shown here with six of her grandchildren: from left to right, Lottie, Virginia, Esmeralda, Beatrice, Loreta, and Alfonso Duarte.

Printed and Sold at the "Southern Californian" Office, Los Angeles.

This Indenture, made the 12th day of December in the year one thousand eight hundred and fifty five Between Andrew Duarte and Pertrudis Duarte resident of Los Angeles County parties of the first part, and Micheal Whistler resident of the Los Angeles County of the second part, Witnesseth, That the said party of the first part, in consideration of the sum of two hundred dollars, to them duly paid before the delivery hereof have bargained and sold, and by these presents do grant and convey to the said party of the second part, his heirs and assigns for ever, All that certain tract or parcel of Land, lying and being in the State of California and Los Angeles County and Bounded and discribed as follows to wit, beginning at a stake it being the South East corner of a survey made for B Norris and more fully discribed as Standing in the west land of an arroyo (no bearing) thence South 70 east seventy five rods to a stake for a corner and the south east corner of this survey from which a bunch of Cedars blar thence north 18 East 213½ rods to a stake for the north east corner of said survey which line crosses the road leading to San Gabriel mision) thence north 70 west 75 rods to a stake for the north west corner of survey from 5 feet of older trees thence south 18 west 213½ rods to the place of beginning together with the right of taking water through our Rancho undisturbed forever with the appurtenances, and all the estate, title and interest, of the said partys of the first part therein. And the said partys of the first part, doth hereby covenant and agree with the said party of the second part, that at the time of the delivery hereof, the said partys of the first part the lawful owner of the premises above granted, and seised thereof in fee simple absolute, and that they will Warrant and Defend the above granted premises in the quiet and peaceable possession of the said party of the second part his heirs and assigns, for ever.

In Witness whereof, the said part of the first part, have hereunto set their hand and seal the day and year first above written.

Sealed and delivered in the presence of

Andrew Duarte (Seal)
his † mark (Seal)

Gertrudis Duarte
her † mark

Land-rich but cash-poor, the Duartes sold four parcels totaling 225 acres beginning in 1855. This deed, dated December 15, 1855, conveys 100 acres to Michael Whistler for $200 and is the second known land transaction. It has the only known signatures of Andres and Gertrudis Duarte. Both, being illiterate, made their marks by writing †. Whistler bought out the three other purchasers and then sold all the land to Nehemiah Beardslee in 1861.

16

The four grandsons of Andres and Gertrudis were, from left to right, (seated) Andres Lucio; (standing) Manuel, Esteban, and Felipe. They were children of Jose Andronico Duarte, the only son of Felipe.

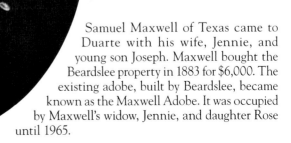

Samuel Maxwell of Texas came to Duarte with his wife, Jennie, and young son Joseph. Maxwell bought the Beardslee property in 1883 for $6,000. The existing adobe, built by Beardslee, became known as the Maxwell Adobe. It was occupied by Maxwell's widow, Jennie, and daughter Rose until 1965.

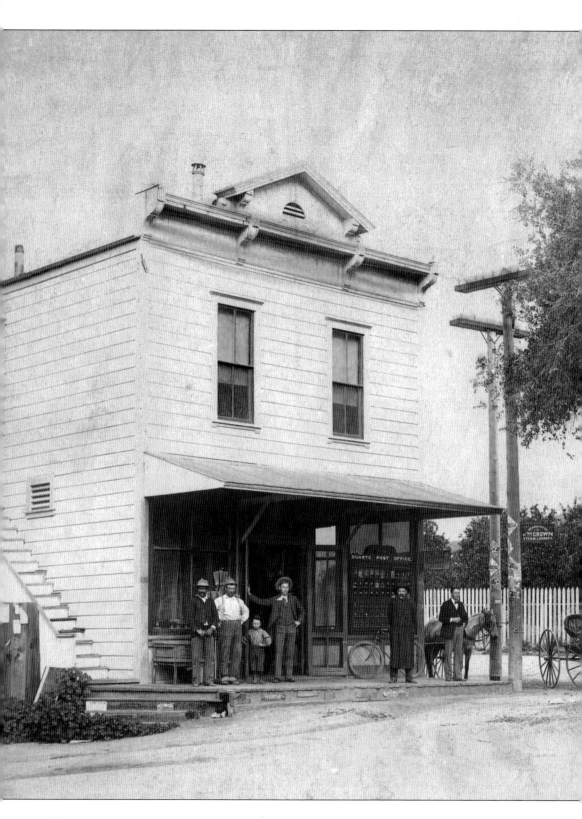

Joseph Fowler, wearing a bandana, was the young man who owned and ran the Duarte Market, pictured here before 1896. His father bought the store for him when he was a child. The store carried a general line of merchandise, including groceries, dry goods, clothing, and hardware. The building also served as the post office and a Crown Steam Laundry branch and provided a public telephone. The second floor held town meetings, dances, and Episcopal church services. The market was at the southwest corner of Royal Oaks Drive (then White Oak) and Highland Avenue (then Foothill). Posters glued to the telephone poles advertise tobacco products and the availability of cash advances. On the porch are, from left to right, unidentified visitor; J. G. Helsley, a teamster; Harry Helsley, his son; Joseph Fowler; Arthur Neeley, clerk; and John Chambers, mail carrier.

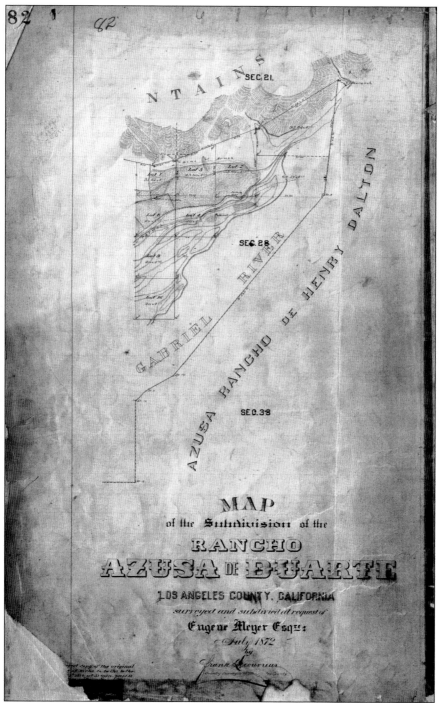

Unable to retire a mortgage, Duarte lost his rancho in 1862. The sheriff sold it for $4,000 to William Wolfskill, who thereafter sold it to Alexander Weil. County surveyor Frank Lecouvreur drew this map (this is the third of three pages) in 1872, subdividing most of the rancho, except for the 225 acres previously sold, into 40-acre lots. Virtually all land transactions in Duarte refer to this map. (Courtesy Los Angeles County Registrar/Recorder.)

The finished style of the Maxwell adobe disguised its basic composition of mud bricks. Nehemiah Beardslee built the first floor after acquiring the 42-acre parcel from Michael Whistler in 1861. He added the second floor in 1872. Rose, Marguerite, and Marie Maxwell were born in the adobe. The adobe was long associated with the Maxwells until Rose died there in 1965. It was demolished in 1968 when no financial support was found for it.

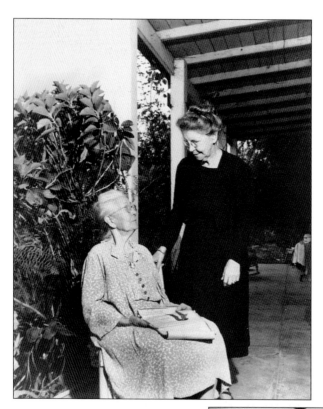

On the veranda of the Maxwell adobe are, from left to right, Jennie (Mrs. Samuel) Maxwell and her sister, Dr. Lula Ellis. Lula Ellis was the first female doctor to graduate from the School of Medicine of the University of Southern California.

The adobe was well furnished in the style of the late 19th century. The Maxwell family's Grovesteen and Fuller square grand piano, built in New York state, probably came to Duarte around 1890. It remained in the adobe until it was razed. It then moved only a few miles to its present location in the Duarte Historical Museum.

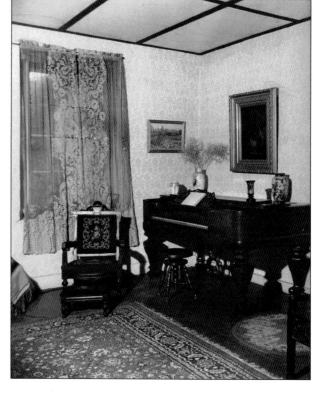

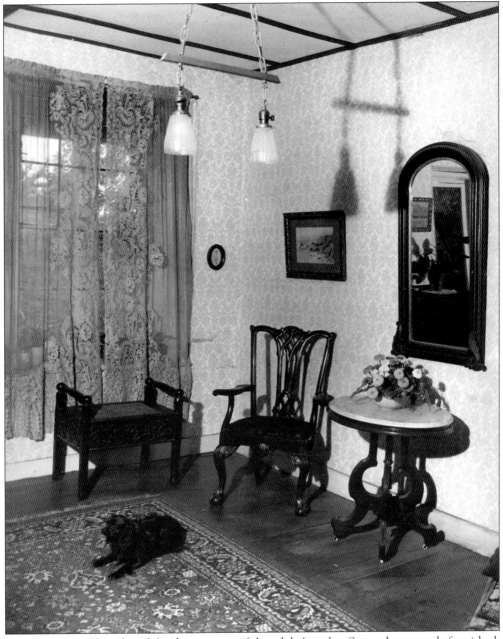

Another view within the adobe shows a part of the adobe's parlor. Somewhat sparsely furnished, the style is late Victorian, with a heavily framed mirror on the wall and a marble-topped table.

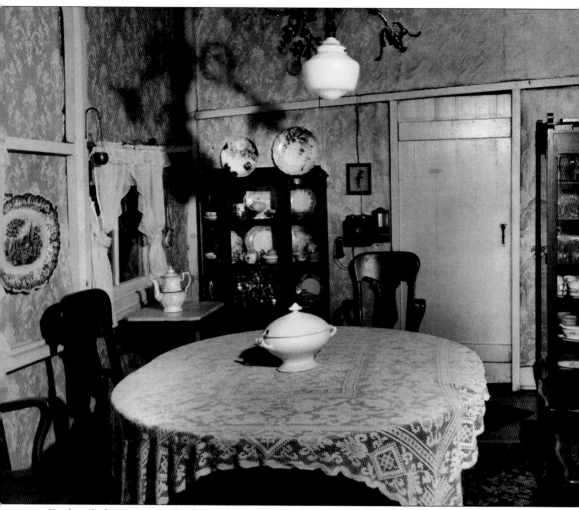

Enclosed glass-windowed cabinets display most of the Maxwell family's ceramic wares, though larger pieces are individually displayed. There is a telephone in this dining room.

Two

Citrus Fruit
and Railways

As cattle ranching yielded to field crops and deciduous fruits "on the Duarte," this, too, gave way to the growing of oranges in abundance. "On the Duarte" became the phrase locals used to distinguish themselves from property east of the San Gabriel River, which was named "on the Azusa." In the first overall history of Duarte, writers Aloysia Moore and Bernice Watson reported that, thanks to its particular soil composition, "the trees and fruit in Duarte [were] much larger, more perfectly formed, juicier, and sweeter than any place else in the State" (*On the Duarte*, page 45).

The County of Los Angeles readily agreed. In 1890, Duarte's oranges garnered first prize at the State Citrus Fair. In addition, a little-known local specialty, the Chappelow avocado, was described in detail in the 1906 USDA Yearbook. Packing houses soon sprang up to support the thriving citrus industry, facilitated by the Southern Pacific Railway's Duarte branch, completed in 1891. Its station was on the site of the present Duarte Fire Station No. 44. The Santa Fe Railway ran south of the town. In 1908, the Pacific Electric Railway was cut through Duarte. The PE's former right-of-way is the present-day walking trail adjacent to Royal Oaks Drive. Though its population remained small, the Queen Colony was off to a good start.

Rail links across the Southland had brought the Foothills Region of the San Gabriel Mountains under the purview of civic improvers as well as entrepreneurs. This was the Progressive Era of American history, and its spirit soon reached out to shape Duarte's early growth. In October 1912, a small group of Jewish philanthropists organized an event at the Los Angeles Philharmonic Theater to raise funds for a proposed sanitorium for victims of tuberculosis. The lower part of the Duarte rancho, land so poor that no one had attempted to farm it, soon housed two small tents to begin the City of Hope Medical Center.

Packing houses, railway links, and a successful sanitorium were added to gains by fruit ranchers, farm families, and civic improvers, laying the foundations of a successful community.

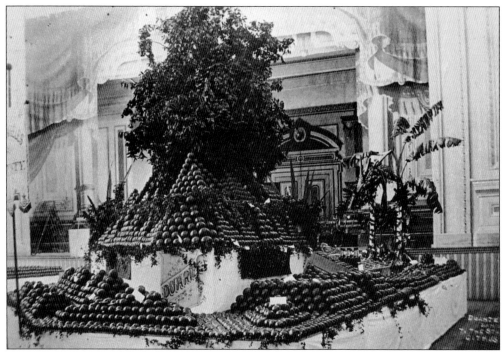

Citrus fruits were found to be a natural match for the climate, soils, and topography of the Duarte rancho. Gradually most of the landowners abandoned field crops, deciduous fruits, and other types of agriculture to concentrate particularly on oranges. By the time of the 1890 state fair, Duarte's oranges were so outstanding that this exhibit celebrated them in the Los Angeles County exhibit.

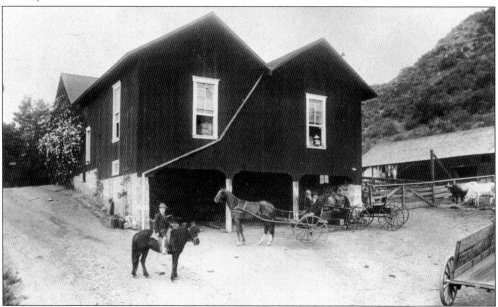

The Thompson ranch was located at the base of the foothills. The top floor of the barn was the packing house. This photograph was taken April 7, 1900. A child was born that day at this ranch. The delivering doctor rode out from Covina and charged $25 for his service.

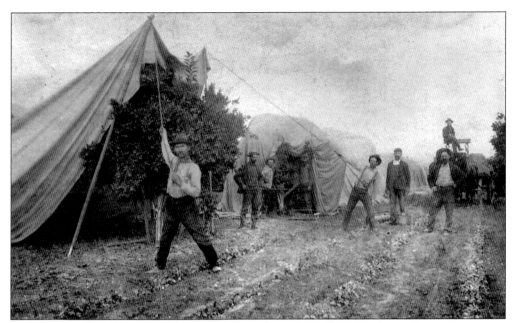

In the earliest days, fumigating the orange orchards was hazardous. Workmen dropped potassium cyanide pellets into a crock containing sulfuric acid. A tent covered the tree and helped to contain the poisonous cyanide gas. This procedure was reasonably effective in killing pests, and the workers generally survived. Later on, spraying with liquid chemical agents that were not so hazardous to personnel made pest control safer for orchard workers.

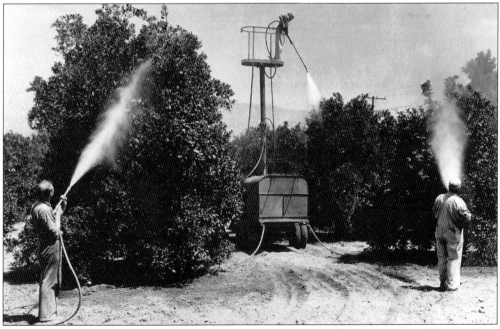

F. H. Felberg applies his spraying apparatus to a Duarte orchard in August 1938. The machine develops a pressure of 450 to 500 pounds per square inch. Each tank holds 500 gallons, and the sprayer can use 15 to 18 tanks per day, spraying to a maximum height of 45 feet. A hydraulic platform raises the tower to 30 feet if required.

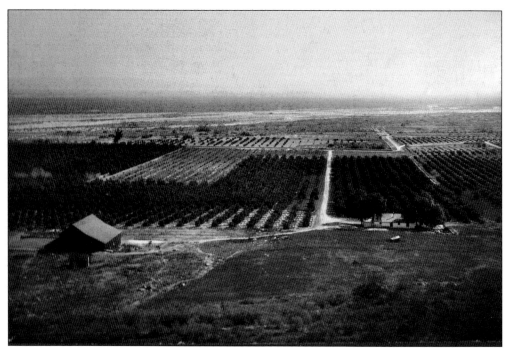

This panoramic view of Duarte orchards about 1900 shows how extensive the orchards were. The diagonal course in the upper part of the photograph is the San Gabriel River before the construction of levees for flood control decades later. (Courtesy Stephen R. Baker.)

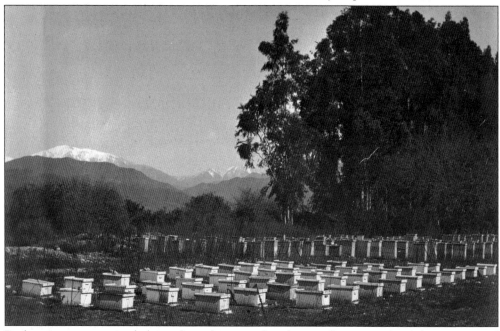

Beekeeping was practiced almost from the start of settlement. Lecouvreur's subdivision map of 1872 notes the location of two "bee ranches" in the uphill areas of the rancho. Bees were valuable both as pollinators of fruits and other crops and for their production of honey. This is a view of the beehives on the Church ranch.

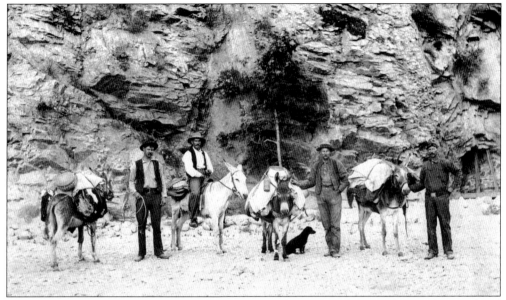

Pack trains, hunting, and exploration were favorite diversions of the settlers as they explored and utilized the mountainous environment just to the north of the settled and cultivated areas of Duarte. This group of four, with their burros, brought along a photographer, who took this well-posed picture. Arthur Church is at the left; the others are not identified.

Twenty-one people, two dogs, and three horses form a group posing for this photograph at the Ernest Watson ranch. At 94 acres, this was one of the largest of the Duarte ranches.

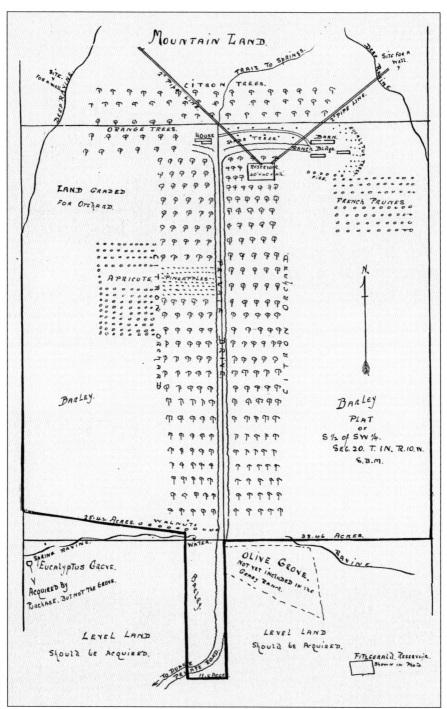

The Geary ranch's schematic map was partly a record and partly a plan, showing actual or projected plantings of oranges, French prunes, Corsican citrons (citrus medica), pineapples, barley, apricots, figs, and walnuts. Citrons were preserved in a complex process and sold as a preserved, sugared rind. This ranch was cited in the *Los Angeles Times* in 1905 as owned by Dr. H. W. Westlake. It produced 600,000 pounds annually, about 200 pounds to the tree.

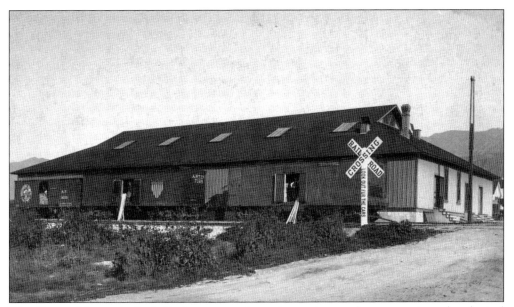

The Duarte-Monrovia Fruit Exchange was formed to enhance the economic and technical interests of the local citrus growers. It operated its own packing house close to the Southern Pacific depot on what is now Highland Avenue near the present site of Los Angeles County Fire Station No. 44.

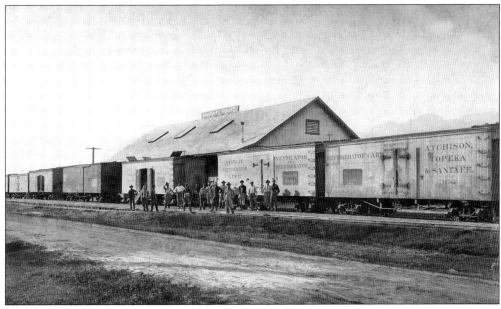

The Atchison, Topeka, and Santa Fe Railway line was completed through Duarte in 1887. This picture shows how extensive the rail operations were in Duarte. Nearly all of the rail operations were devoted to the shipment of oranges. The Santa Fe's shipments of fruit from California as a whole were 7,000 railcars in 1900, with oranges predominating.

A pipe smoker in a bowler hat waits with two children at the Santa Fe's West Duarte station. The fringes on the roof ridges of the station building are also seen on other buildings of the period. A packing house stood just west of this station, and the stationmaster's house still stands on Buena Vista Street north of the tracks. The Santa Fe right-of-way is to be reused for the Metro Rail Gold Line.

The north side of the West Duarte Santa Fe packing house looked like this about 1896.

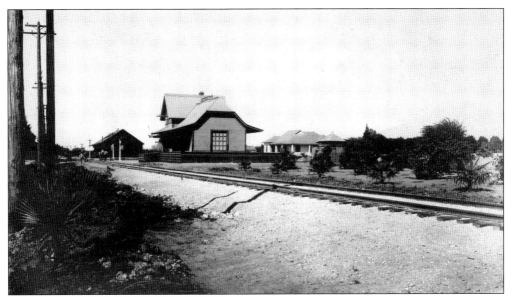

Looking west at the Santa Fe Railway's West Duarte Station, one can see the Duarte-Monrovia Fruit Exchange orange packing house beyond and the stationmaster's house on the right. The stationmaster's house still stands north of the existing rail right-of-way just west of Buena Vista Street.

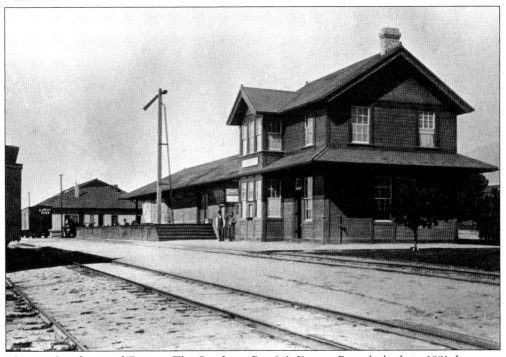

Three railroads served Duarte. The Southern Pacific's Duarte Branch, built in 1891, began at the main line in Alhambra and passed through San Marino, Arcadia, and Monrovia, ending at Las Lomas in Duarte. When the Pacific Electric was built in 1908, Southern Pacific's line was extended to enable the PE to carry Southern Pacific traffic to Glendora. This is the SP's station on Highland Avenue.

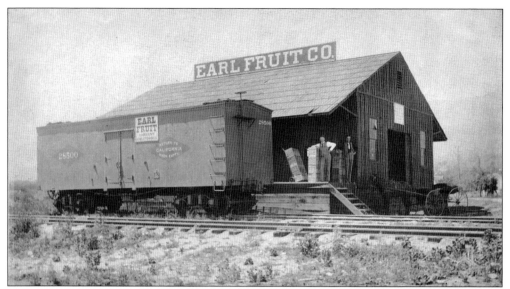

The Earl Fruit packing house was close to the West Duarte Santa Fe station that was built in 1886. The packing house was built a few years later. Packing houses were essential parts of the citrus industry. Several were built in Duarte, but none remain. There were several pictures of local packing houses. The identification is uncertain for some of them.

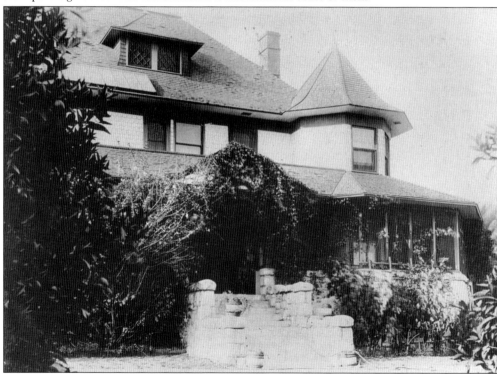

The Maddock family built this Queen Anne–style house in 1900 after their less impressive original house burned. They continued to occupy it for decades. The Maddocks had a large and successful orange-growing operation. The house was extensively renovated to adapt it for what became a brief period as a bed-and-breakfast during the 1990s but was later returned to use as a residence.

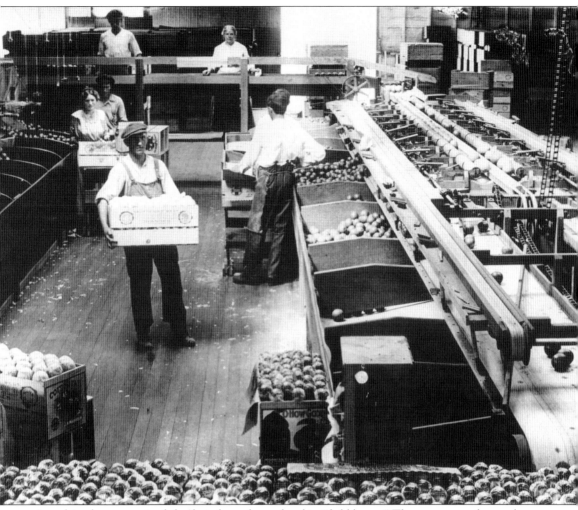

A packing house received the fruit from the orchard in "field boxes." These were sturdy wooden containers that made repeated trips between orchard and packing house and usually had the grower's or the cooperative's name on them. They contained about 60 pounds of fruit each when full. Packing-house operations included sizing, culling of lower-quality fruit, washing, packing into crates, labeling, and shipping. This is the Maddock packing house about 1912.

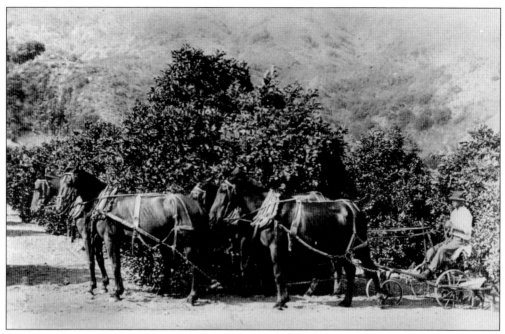

Horses were the chief motive power for wagons, picking activities, and transportation in the early days, as shown here on the Maddock ranch and in photographs of railroad activities, blacksmithing, and so on.

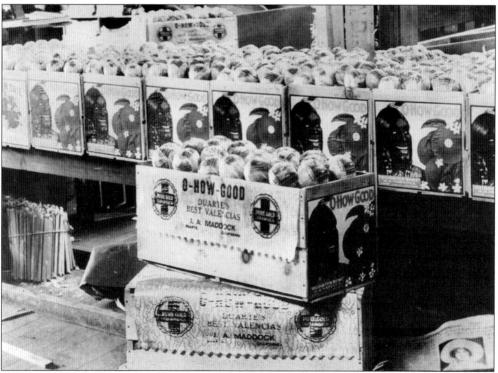

Some label designs that are now thought to be less than socially acceptable were considered whimsical during the heyday of orange crate labeling.

Arthur Handyside came to Duarte by invitation after the accidental death of Arthur Maddock in 1903 to manage the Maddock's agricultural operations. Here he is with his family. From left to right are (on ground) Alice; (seated) Florence Handyside and infant Robert; (standing) Arthur, Enid, and Lorraine. Arthur himself died after six years, of complications from a ruptured appendix.

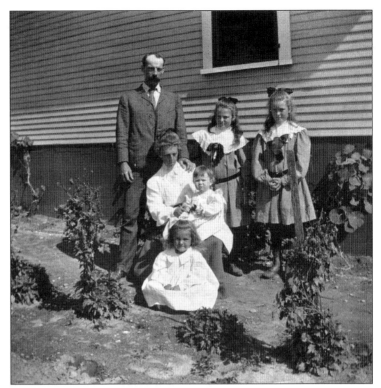

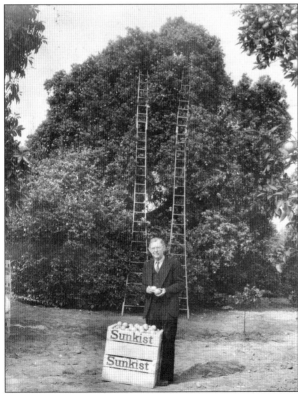

Emmett B. Norman is shown near an orange tree that was planted by his father in 1876. It measured 37 feet in height and had a spread of 90 feet. This was the largest Valencia orange tree in Southern California as of 1943. Norman wrote a valuable, illustrated, and comprehensive history of the early citrus industry in Duarte. He played himself in the 1941 historical pageant.

Eugene D. Northup was a prominent and successful grower of oranges in Duarte.

Northup chose (for reasons not known) to identify his operation as "Inglenook on the Duarte," although handwritten notations on the original photographs of the period consistently spelled it "Ingleneuk." He posed his wife and daughters in the orange trees and called them his "roses." From left to right are Aileen, Belle (on the ladder), and Jennie.

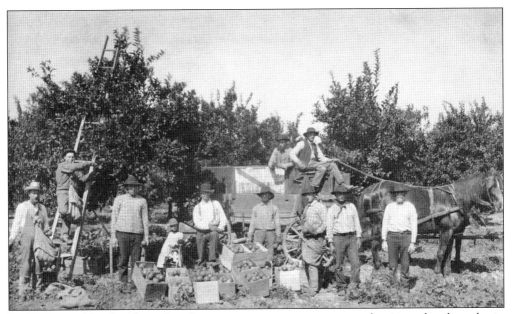

Earlier scenes like this show that the orange groves were not so neatly trimmed and regular in appearance. Compare this Northup field group (including little Aileen) and its orchard environment to later pictures showing highly regular rows of precisely trimmed trees. The field boxes do not yet carry the "Inglenook" logo used later by Northup and are built with a center partition, unlike the later field boxes.

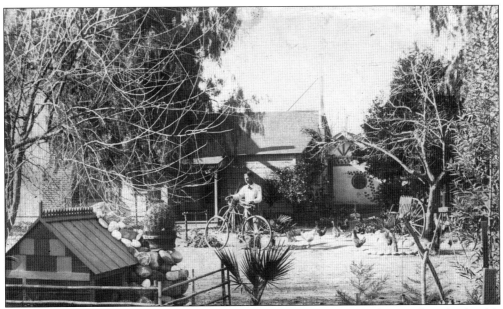

Fred Northup holds his bicycle in this 1893 photograph. With him in the barnyard are the family's chickens. The small shed in the foreground is decorated with an architectural fringe on its ridge, similar to the decorative fringe on the roof of the West Duarte Santa Fe station.

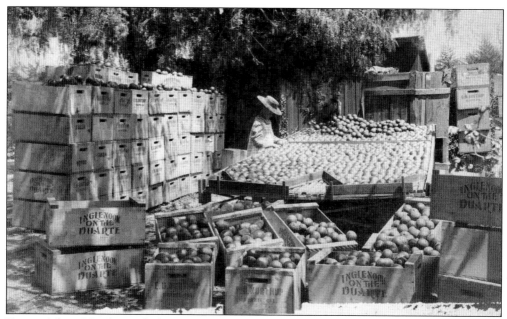

Young Aileen Northup is helping to examine and sort oranges in field boxes on their way to the packing house. The very prominent "Inglenook on the Duarte" logo is stamped on every field box.

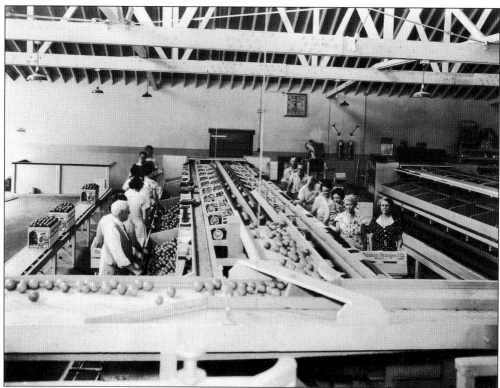

By 1938, the Duarte Foothill citrus packing house had adopted some modern sorting and packing equipment.

Water was critical to the agricultural community. Rights to water from Andres Duarte's own ditch from the San Gabriel River were conveyed with the first deeds. The Beardslee Water Ditch Company was organized shortly thereafter. Its successor was the Duarte Mutual Irrigation and Canal Company, organized in 1882. Landowners were entitled to own a specific number of shares. Despite the name, there was never a "canal."

Duarte Mutual Irrigation and Canal Company

Incorporated January 1, 1882

By-Laws

As Adopted March 13, 1920

With a Copy of

The Compromise Agreement and the Decree of the United States Circuit Court, 1895

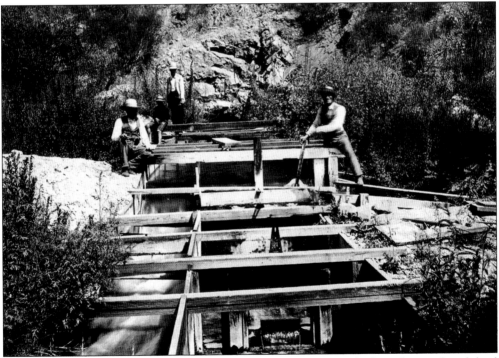

Disputes about the division of the scarce San Gabriel River water resulted in a decision by a federal district court that divided the resource into 720 parts and allocated them in various proportions to the claimants. The original wooden division box is long gone, but it was replaced by one built of concrete that continues to function well over a century after the original was installed, in the same place.

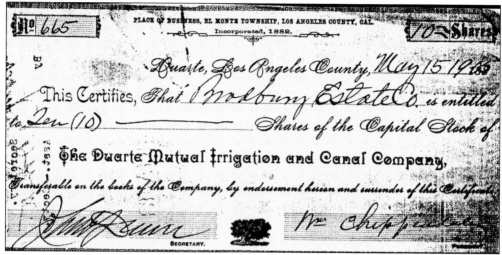

No 665 PLACE OF BUSINESS, EL MONTE TOWNSHIP, LOS ANGELES COUNTY, CAL.
Incorporated, 1882. 10 Shares

Duarte, Los Angeles County, May 15 19—

This Certifies, That *Bradbury Estate Co.* is entitled to *Ten (10)* Shares of the Capital Stock of

The Duarte Mutual Irrigation and Canal Company,

Transferable on the books of the Company, by endorsement hereon and surrender of this Certificate.

SECRETARY.

W.H. Chippendale

Shares of the water company were issued generally in proportion to acreage owned. William Chippendale, the president, signed this 10-share certificate issued to the Bradbury Estate Company. Chippendale was himself an owner of citrus acreage and was prominent in local affairs. The share certificates were signed by the president and secretary.

Old Engine No. 58 ran from San Bernardino to Los Angeles on the main line of the Santa Fe. Here it is being serviced at the West Duarte station, then a packing house.

Fruit was shipped to distant grocers and consumers in light, one-way wooden crates. Each crate usually carried a lithographed label that could be unique, as here with St. Patrick's, or more generic in style, where the printer supplied a format and the name of the individual grower and locality would be imprinted. The Fitzgeralds used the St. Patrick label for their highest quality oranges.

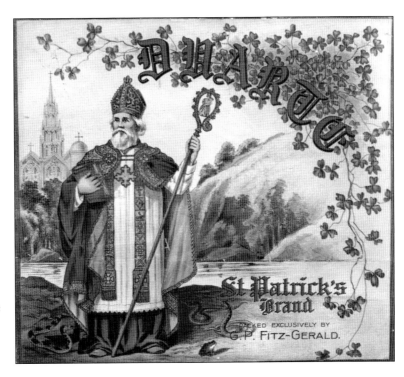

The black-and-white reproductions of most labels, including these St. Patrick and Primrose labels, do not do justice to the colorful originals.

Two more orange crate labels were the Duarte Beauties and the Young America. The Sunkist brand is shown on this Duarte Beauties label.

The Young America label represented one of the thriving citrus growers in the Duarte area.

The Maddocks used the Duarte Oranges Magnum Bonum label. The lightweight orange crates or boxes provided convenient wood supplies for small boys who built carts, wagons, and other devices far away from Duarte and California.

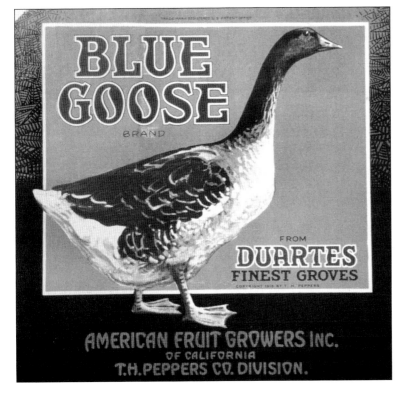

In all, there were about 28 orange-crate labels used by the Duarte fruit growers. The artists who designed them were largely anonymous.

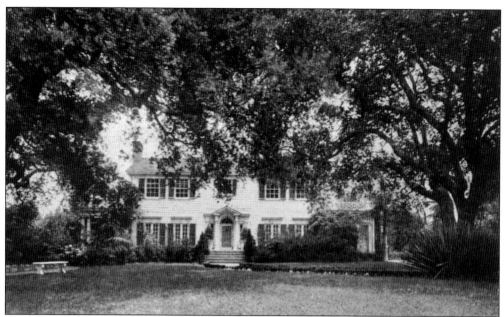

William Woolwine, a Los Angeles banker, lived in Duarte. Because of the very large oaks on his property, he named his house Royal Oaks; it was just north of the Pacific Electric line. Woolwine was probably a Red Car commuter during the 1920s. Royal Oaks Drive gets its name from this house.

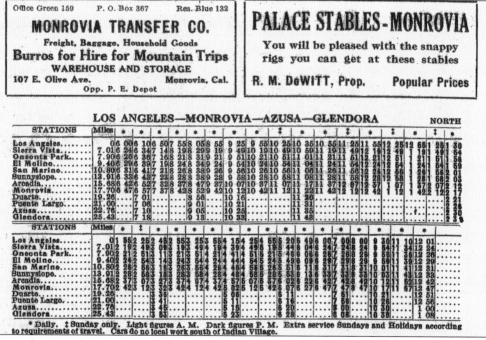

LOS ANGELES—MONROVIA—AZUSA—GLENDORA — NORTH

STATIONS	Miles																			
Los Angeles	.0	6 00	6 10	6 50	7 55	8 05	8 55	9 25	9 55	10 25	10 35	10 55	11 25	11 55	12 25	12 55	1 30			
Sierra Vista	7.01	6 24	6 34	7 14	8 19	8 29	9 19	9 49	10 19	10 49	10 59	11 19	11 49	12 19	12 49	1 19	1 54			
Oneonta Park	7.90	6 26	6 36	7 16	8 21	8 31	9 21	9 51	10 21	10 51	11 01	11 21	11 51	12 21	12 51	1 21	1 56			
El Molino	9.40	6 29	6 39	7 19	8 24	8 34	9 24	9 54	10 24	10 54	11 04	11 24	11 54	12 24	12 54	1 24	1 59			
San Marino	10.80	6 31	6 41	7 21	8 26	8 36	9 26	9 56	10 26	10 56	11 06	11 26	11 56	12 26	12 56	1 26	2 01			
Sunnyslope	13.91	6 43	7 23	8 28	8 38	9 28	9 58	10 28	10 58	11 08	11 28	11 58	12 28	12 58	1 28	2 03				
Arcadia	15.68	6 42	6 52	7 32	8 37	8 47	9 37	10 07	10 37	11 07	11 17	11 37	12 07	12 37	1 07	1 37	2 07			
Monrovia	17.70	6 47	6 57	7 37	8 42	8 52	9 42	10 12	10 42	11 12	11 22	11 42	12 12	12 42	1 12	1 42	2 12			
Duarte	19.26		7 01			8 56		10 16			11 26						2 21			
Puente Largo	21.00		7 06			9 01		10 21			11 31						2 26			
Azusa	22.76		7 10			9 05		10 25			11 35						2 30			
Glendora	25.43		7 18			9 13		10 33			11 43						2 39			

STATIONS	Miles																		
Los Angeles	.0	1 55	2 25	2 55	3 55	3 25	3 55	4 15	4 25	4 55	5 20	5 40	6 00	7 00	8 00	9 30	11 10	12 01	
Sierra Vista	7.01	2 19	2 49	3 19	3 49	4 19	4 49	5 09	5 19	5 49		6 24	6 58	7 24	8 24	8 54	11 34	12 24	
Oneonta Park	7.90	2 21	2 51	3 21	3 51	4 21	4 51	5 11	5 21	5 51	6 09	6 26	7 00	7 26	8 26	9 56	11 36	12 26	
El Molino	9.40	2 24	2 54	3 24	3 54	4 24	4 54	5 14	5 24	5 54	6 11	6 29	7 03	7 29	8 29	9 59	11 39	12 29	
San Marino	10.80	2 26	2 56	3 26	3 56	4 26	4 56	5 16	5 26	5 56	6 13	6 31	7 05	7 31	8 31	10 01	11 41	12 31	
Sunnyslope	13.91	2 38	3 08	3 38	4 08	4 38	5 08	5 28	5 38	6 08		6 43	7 17	7 43	8 43	10 13	11 43	12 33	
Arcadia	15.68	2 37	3 07	3 37	4 07	4 37	5 07	5 27	5 37	6 07	6 22	6 42	7 16	7 42	8 42	10 12	11 57	12 42	
Monrovia	17.70	2 42	3 12	3 42	4 12	4 42	5 12	5 32	5 42	6 12	6 27	6 47	7 21	7 47	8 47	10 17	11 57	12 51	
Duarte	19.26		3 36			5 06			6 11						9 51	10 21		12 51	
Puente Largo	21.00		3 41			5 11			6 16						9 56	10 26		12 56	
Azusa	22.76		3 45			5 15			6 20						10 00	10 30		1 00	
Glendora	25.43		3 53			5 23			6 28						10 08	10 38		1 08	

* Daily. ‡ Sunday only. Light figures A. M. Dark figures P. M. Extra service Sundays and Holidays according to requirements of travel. Cars do no local work south of Indian Village.

From the Consolidated Time Tables of the Pacific Electric system of July 1911, one gets an idea of the frequency and travel time of rail passenger service between Duarte and downtown Los Angeles. Running time was about 50 minutes. Passengers also traveled between local stations. Also, for those so inclined, burros were for rent for use in trips to the mountains. (Courtesy Douglas Klaas.)

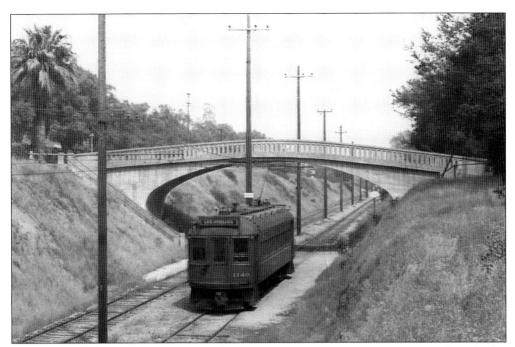

Pacific Electric Red Car 1140 is making its way to Glendora, passing under the Bradbury bridge at Oak Avenue in Duarte. The Red Cars passed through essentially open country in Duarte. The original stairs from street level down to the track level are shown here on the north side; the renovation of the bridge rebuilt them on the south. (Courtesy Douglas Klaas.)

Duarte once had its own avocado. In 1893, William Chappelow planted four seeds from the U. S. Department of Agriculture that came from a Mexican tree that had withstood frost without losing its crop. One tree grew to immense size and was famous locally. The variety was described in the 1906 USDA Yearbook. Unfortunately, no tree or genetic material has, to our knowledge, survived. The Chappelow avocado has been lost.

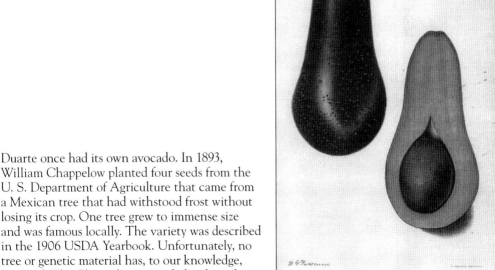

Buena Vista is now a major street, but from 1875 to 1885, it was this unpaved road heading north from the Santa Fe Railway toward the mountains. The recently built Southern Pacific Line is about half a mile north, and the First Duarte School is a few hundred yards north on the left. (Neither is visible in this photograph.) Buena Vista is the dividing line between Townships X West and XI West, referring to the San Bernardino Base Line and Meridian, of the U. S. Public Lands system in Southern California. Children's geography books used to explain the terminology of the Public Lands system, but the subject is now an arcane specialty.

Ida May Shrode is shown here at 58, the year she earned her doctorate at the University of Chicago. She taught geography from 1924 to 1952 at Pasadena Community College. She was a director of the Duarte-Monrovia Fruit Exchange, a founder of the Duarte Historical Society, a member of the Association of American Geographers, and active in many civic undertakings. (Courtesy Ruth Crist.)

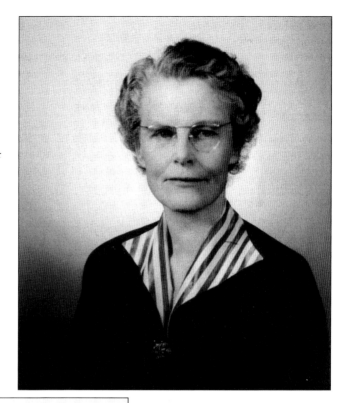

The University of Chicago

THE SEQUENT OCCUPANCE OF
THE RANCHO AZUSA DE DUARTE
A SEGMENT OF THE UPPER SAN
GABRIEL VALLEY OF CALIFORNIA

A DISSERTATION SUBMITTED TO THE FACULTY OF
THE DIVISION OF THE PHYSICAL SCIENCES IN
CANDIDACY FOR THE DEGREE OF DOCTOR OF
PHILOSOPHY

DEPARTMENT OF GEOGRAPHY
JUNE, 1948

By
IDA MAY SHRODE

CHICAGO, ILLINOIS
1948

As a geographer and teacher, Ida May Shrode meticulously described in her dissertation how the Duarte rancho's land use developed over the years. This work is a comprehensive compilation of information on land use, agricultural practices, and social and business conditions on the Duarte rancho during the 19th and early 20th century.

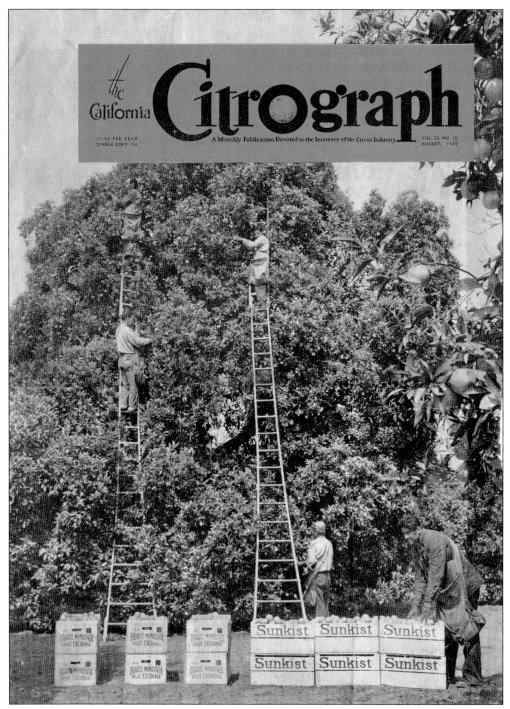

The citrus industry was important enough to support both specialized publications and the manufacture of equipment. The *California Citrograph* magazine was published in Los Angeles. This is the August 1943 cover. The tree shown is on the E. B. Norman ranch on South Mountain Avenue. The field boxes show the logo of the Duarte-Monrovia Fruit Exchange.

Three

SETTLERS AND SCHOOLS

The *Monrovia Planet* of January 8, 1887, offered the following synopsis: "The settlement of Duarte is in every respect a model one without saloons or disreputable resorts of any kind, and any owner of any property in the village who shall attempt to start a saloon will forfeit his rights to the property. It is a charming place for homes, and the rich and growing settlement will undoubtedly develop into a thrifty and prosperous village."

A thriving citrus industry drew upon a cooperative workforce of indigenous Mexican Americans and imported African Americans, some brought in by the legendary "Lucky" Baldwin. Duarte's leading lights soon settled down to the Victorian imperatives of self-improvement, education, and picnics. Tea was served in the afternoons after games of tennis as a sort of genteel lifestyle sprang up, especially among those settlers who moved in from England and attended the Episcopal church, which met upstairs in the old Duarte Market at the corner of Highland Avenue and Royal Oaks Drive.

Many of the American settlers pouring in were Methodists and Presbyterians, devoted to religious instruction and especially to education. Instruction in the old Beardslee milk shed was replaced by the First Duarte School in 1878. When this was moved to Monrovia, the Second Duarte School, a handsome two-story structure, replaced it. However, the Second Duarte School burned in 1908. Replacing that one in 1909—at the then almost princely sum of $16,000—was the Third Duarte School, a beautiful city landmark to this day.

Today's Duarte Unified School District traces its roots back to 1906, when Duarte youngsters were shipped to school in nearby Monrovia as part of the Monrovia-Arcadia-Duarte School District, an arrangement that lasted until 1954. Meanwhile, in the Davis Addition, an early subdivision owned by Los Angeles entrepreneur Charles C. Davis, African American children attended their own Davis School in the well-remembered "Rocktown" community.

Pictures preserved by the Duarte Historical Society evidence the surprising fact that the 1909 school was ethnically integrated long before this became the pattern nationwide.

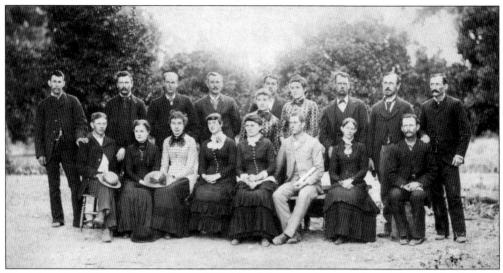

Picnickers in 1883 at a frequently used Highland Avenue site were, from left to right, (seated) Emmett B. Norman, Helen Shrode (Mrs. Daniels), Helen Graves (Mrs. Davisson), Carrie Davisson (Mrs. Young), Viola Shrode (Mrs. Norman), Stephen A. D. Clark, Belle Norman (Mrs. R. R. Smith), and F. M. (Maje) Shrode; (standing) Elmer Trask, Charles A. Shrode, Ben R. Davisson, Bloomer White, Jennie Shrode, Seth F. Daniels, Frankie Wardell (Mrs. Mosher), Jacob H. Shrode, Will Bliss, and William R. Beardslee. (All married names were acquired later.)

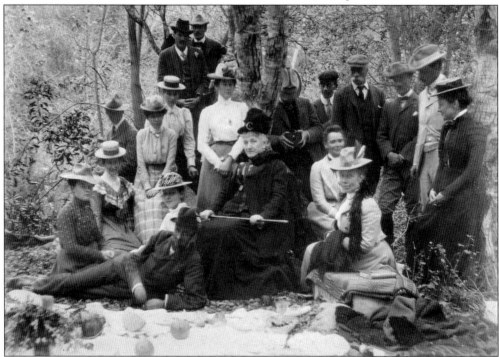

This picture of a mountain picnic, probably taken in Fish Canyon, includes members of the elegantly dressed Scott, Wright, and Maddock families. A gentleman in the center is taking a picture of the photographer; unfortunately, there is not a copy. But not all picnics were as formal, as another photograph shows.

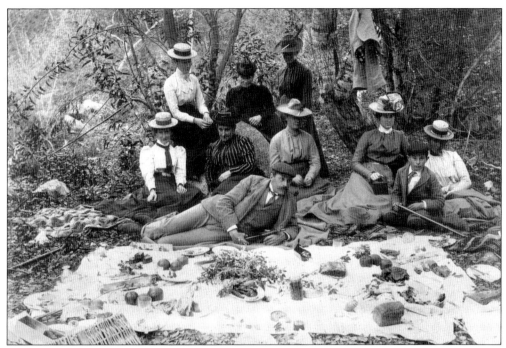

In the late 1800s are members of the Young, Scott, and Wright families along with Sarah (Mrs. John) Scott's sister, visiting from England. The photograph was probably taken in Fish Canyon.

Not all picnics were in the genteel style or the clothing elegant. Some "picnics" might have represented an alternative to overcrowding in the small houses of the period. This group is on some rough and uncultivated terrain.

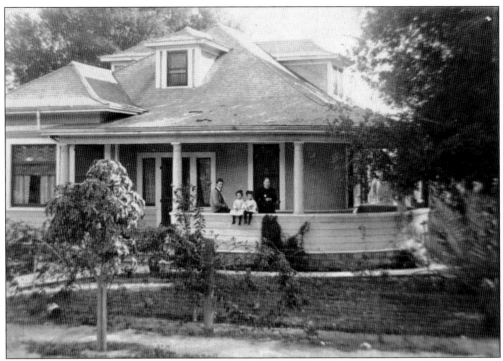

Joe Fowler, proprietor of the Duarte Market, built his home just 100 yards west of his market. It still stands essentially unchanged since the early 1900s.

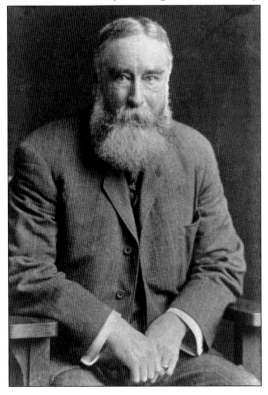

John Scott, born in Lancashire, England, in 1845, emigrated to Canada in 1877 and to Duarte in 1882. He became the first horticultural commissioner of Los Angeles County. As a citrus grower, he won many local and national awards. Some of his laboratory equipment is on display in the Duarte Historical Museum. His granddaughter Margaret Scott Meier was active in local history as curator of the museum.

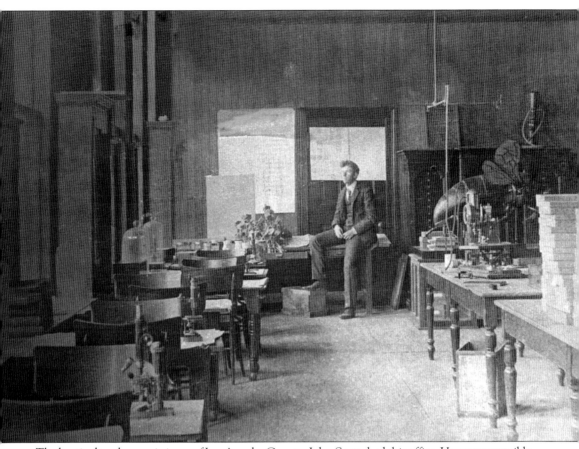

The horticultural commissioner of Los Angeles County, John Scott, had this office. He was responsible for stamping out all insect parasites that attack fruit trees and preventing their importation. His staff of 30 inspectors examined all nursery stock and burned all infected trees.

The Reverend David S. Shrode organized Duarte's first Sunday school and was its superintendent until 1895. He was a board member of the Monrovia-Duarte Citrus Packing Plant and the Beardslee Water Ditch Company. Shrode Avenue is named for him. The diary of David's wife, Maria Christina Hargrave Shrode, written during their trip to California, was published by the Huntington Library in 1980 in *Ho for California!* (Courtesy Sidney K. Gally.)

Pictured here is Dr. Susan Jane (Jennie) Shrode, daughter of David Shrode and sister of Dr. David Lee Shrode, whose picture is on page 60. (Courtesy Sidney K. Gally.)

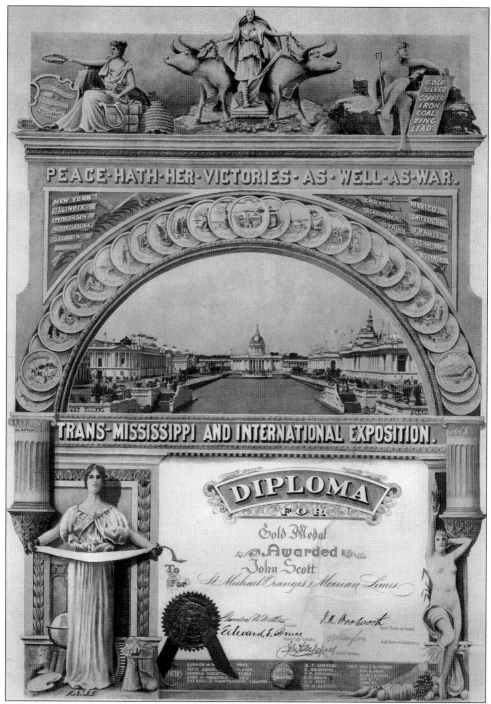

This extravagant Gold Medal diploma was awarded at the Trans-Mississippi and International Exposition to John Scott of Duarte for his exceptional St. Michael oranges and Mexican limes. Scott also received a Bronze Medal Diploma at the same exposition for his Meredith sweet oranges and Valencia late oranges. Only the small corporate seal mentions where, but not when, it was awarded. It was in Omaha, Nebraska, in 1898.

This blacksmith shop was originally David Shaw Shrode's (1825–1895). He ran the shop for 12 years. The name F. M. Shrode above the sign is that of David's son Francis Marion Shrode, known in the family as "Uncle Maj." He is standing by the horse; he also ran the shop for many years. To his right are, from left to right, an unidentified man and his two brothers Jacob Hudson Shrode ("Uncle Jake") and Charles Allen Shrode ("Uncle Doc"). (Courtesy Sidney K. Gally.)

A close-up of the Shrode house adjacent to their blacksmith shop shows that, even on the frontier, the quality of carpentry and architectural detail was high indeed. The Duarte Market building shows similar excellence.

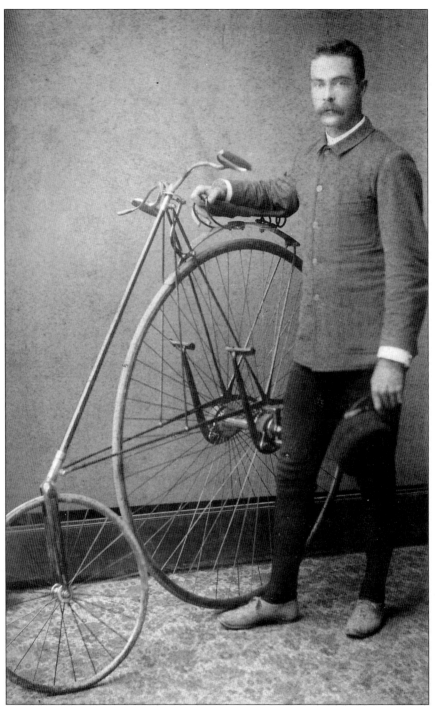

The American Star Safety Highwheeler bicycle was invented in 1880. The ratcheting crank system and very large rear-driven wheel made for very high speeds, but the small front wheel made the bicycle skittish on sand and gravel. Dr. David Lee Shrode was an athlete who obviously enjoyed riding his sporty new acquisition. It probably had little to do with his death at an early age. (Courtesy Sidney K. Gally.)

Lewis Leonard Bradbury, a mining engineer, made his fortune in Mexico. Moving to California, he bought 2,750 acres of the former Duarte rancho. There he established a country home while he lived in an elaborate home in Los Angeles. The city of Bradbury is named for him, and some of its boundaries are the same lines established by Henry Hancock in his first map of the rancho in 1858. (Courtesy City of Bradbury.)

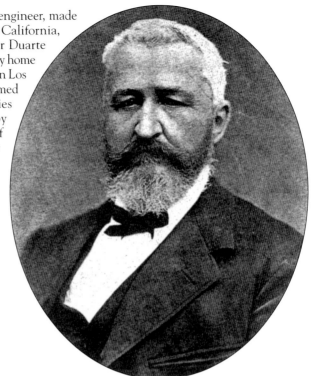

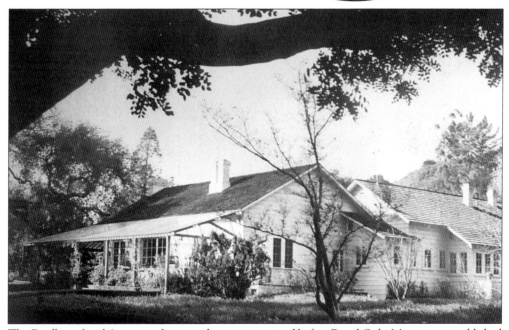

The Bradbury family's country home is shown as it existed before Royal Oaks Manor was established as a retirement home on a small remnant of the original Bradbury land purchase. Royal Oaks Manor, operated by Southern California Presbyterian Homes, is an unincorporated enclave of Los Angeles County, part neither of the city of Bradbury nor of the city of Duarte. (Courtesy Royal Oaks Manor.)

61

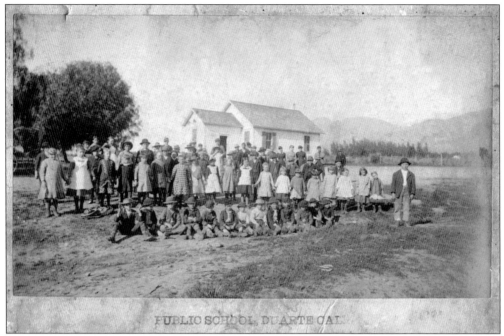

PUBLIC SCHOOL, DUARTE CAL.

In 1873, Alexander Weil donated a plot of land at the intersection of Central Avenue and Buena Vista Street for public education. A primary school was built there. It was so overcrowded that in a little over a decade it had to be replaced by a larger school. This First Duarte School was moved to Monrovia, where it remains. The photograph dates from 1885.

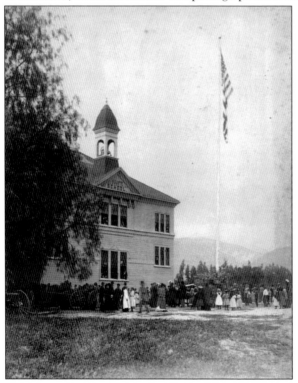

The replacement for the First Duarte School was a handsome and spacious two-story building, the Second Duarte School. It had eight large classrooms, offices, and an assembly hall. It was built in 1896 but burned in 1908.

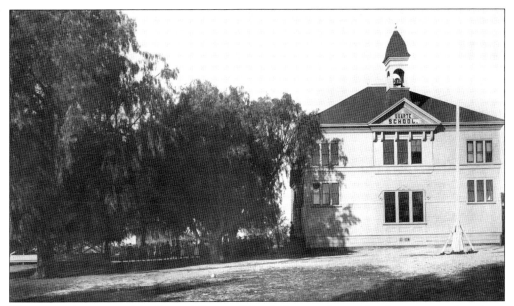

This is another view of the Second Duarte School. It was taken with a large group of students in the shadows of the trees on the left, with two teachers facing them on the school's steps. (Courtesy Sidney K. Gally.)

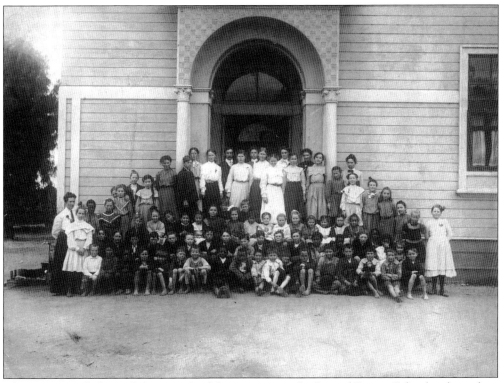

This is a particularly good photograph of the entrance to the Second Duarte School with teachers and students.

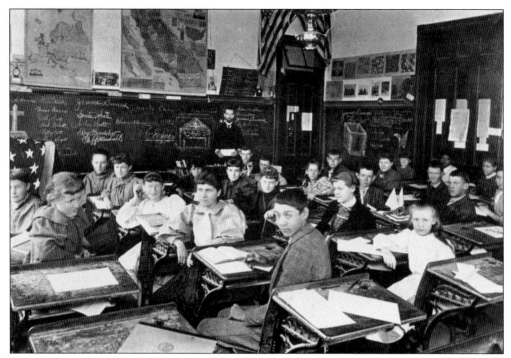

This mixed-grade geography class at the Second Duarte School, on June 14, 1895, shows C. E. Locke, the teacher, with his students and with many of the students' names written on the blackboard. Several members of the Scott family are shown, and their family's geography book, used (and extensively scribbled in) by several of the Scott children, is on a desk in the foreground.

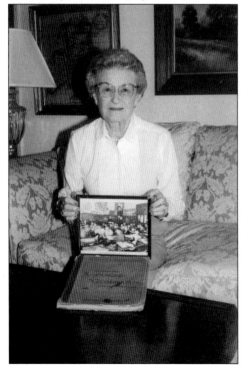

A century later, on June 14, 1995, Margaret Scott Meier holds the picture of Locke's 1895 geography class as well as the book shown 100 years before. Her father is one of the Scott children in the picture. (Courtesy Irwin B. Margiloff.)

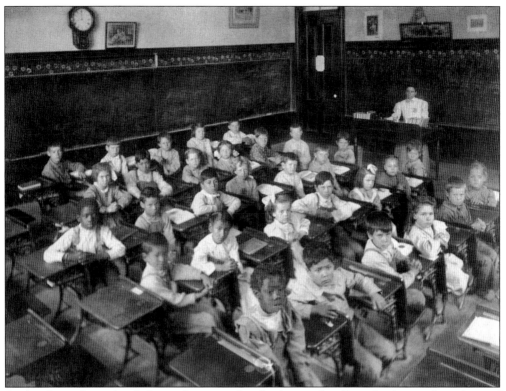

At the classical wooden desks, each equipped with a brass inkwell, sit the first-grade students of the Second Duarte School on May 22, 1907. Palmer method letters are written on the blackboard as examples for students to emulate. Carolina Carter presides.

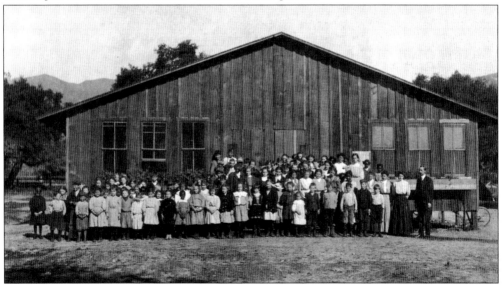

Needing a place to conduct their classes after the Second Duarte School burned, Duarte's schoolchildren were educated in a temporary school on E. H. Boden's property, in a new barn, just north of the Blue Gum Eucalyptus Grove. This lasted for a year until the Third Duarte School was completed.

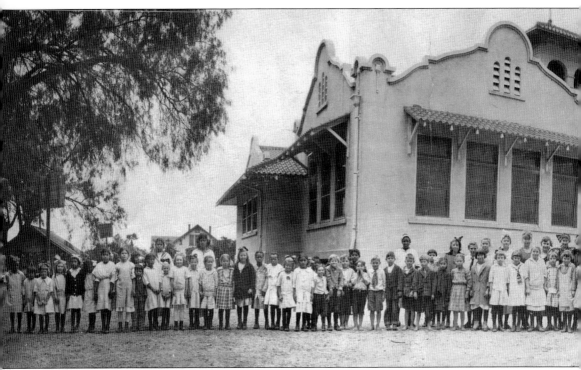

After the Second Duarte School burned, this Third Duarte School, costing $16,000, was completed in 1909 on the same site. Designed by F. S. Allen, the school contained five large classrooms, an auditorium, and offices in its first- and second-floor towers. It became the communal icon of Duarte, and innumerable pictures have been taken of it and of its students and teachers. The building was supplanted by more modern schools after World War II. It served for several years as

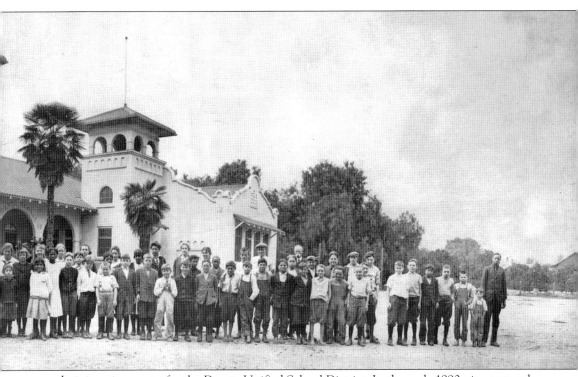

an administrative center for the Duarte Unified School District. In the early 1990s, it was saved from demolition by a citizens' campaign and was converted, at a cost of about $2 million, into a successful and popular restaurant by the Old Spaghetti Factory, a chain that preserves historic buildings by adapting them as restaurants. Its classrooms and many original details still in place remind visitors of its academic origin.

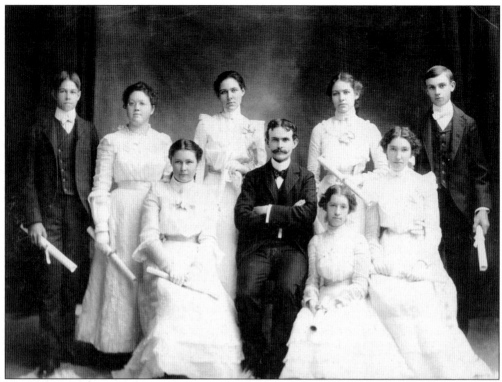

This elegantly dressed group is the Duarte School's graduating class of 1901.

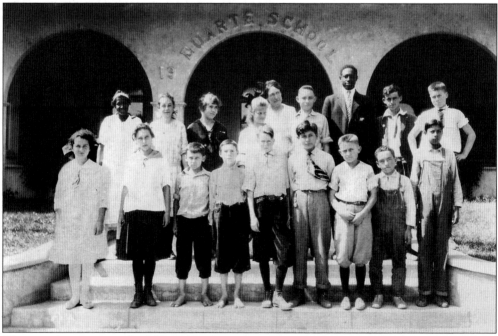

These students were in the fifth and sixth grades of the Third Duarte School at the end of the school year in 1925.

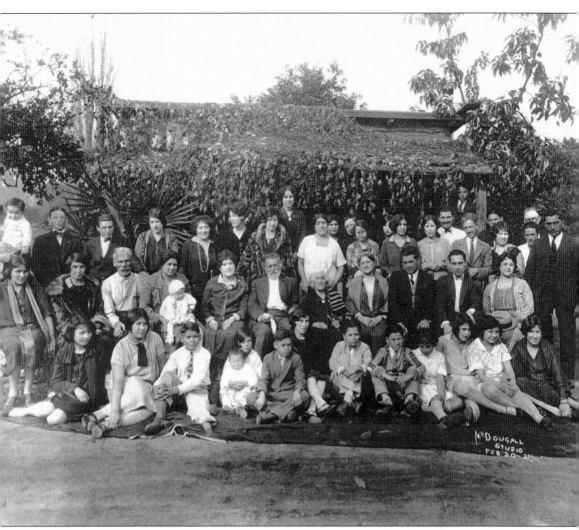

Friends and relatives met at the 60-acre Duarte ranch on South Mountain Avenue on February 20, 1927, to celebrate the 100th birthday of Maria de Jesus Lopez de Marron, widow of Felipe Santiago Duarte. She is the elderly lady in the center of the middle row. Many family members were born at this ranch. It was acquired in the late 1800s and stayed in Duarte family ownership until 1936.

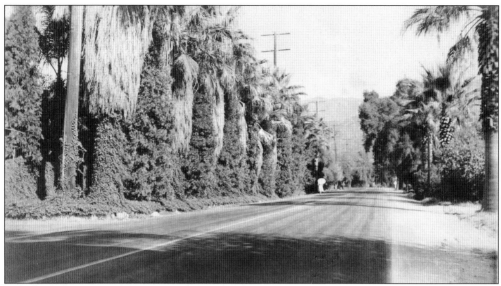

Duarte's streets were generally semi-rural at best during this period. This is a view of Highland Avenue, looking north of Foothill, before the construction of major residential developments.

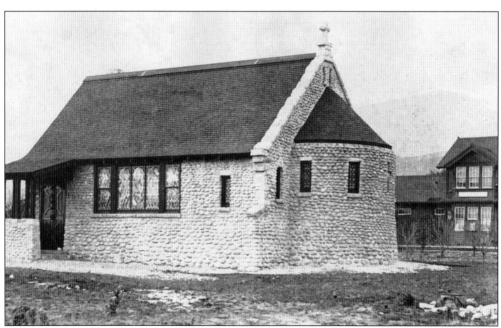

Episcopalians organized a new congregation at the Highland Hotel in October 1889 and later above the Duarte Market and at a packing house. Arthur B. Benton designed this Norman-style church. The cornerstone was laid on All Saints Day in November 1898 near the site of the present county fire station. For four years, the parishioners moved stones in their wagons from the San Gabriel River to erect the structure. Stained-glass windows came from England.

The altar of All Saints Mission looked like this on September 7, 1911, at the wedding of Gordon Maddock and Kathryn Jackson. A floral wedding bell hangs above the altar.

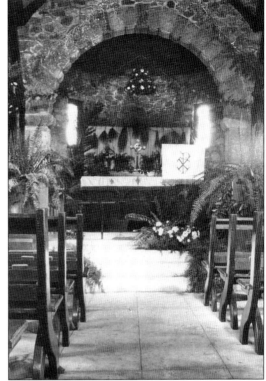

The interior of All Saints Mission shows a truss roof and a simple style of masonry. Deconsecrated, the building became the Chapel Inn restaurant and then an American Legion post. It was demolished illegally during Thanksgiving weekend in 1964.

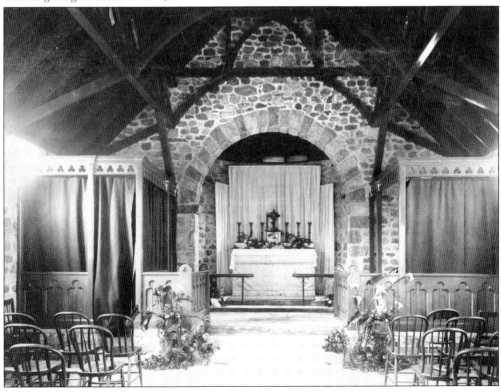

Capt. Gerald P. Fitzgerald, of Her Majesty's Irish Guards, came to Duarte from Ireland in 1892 with his wife, Alice Susan, the former Lady Gatacre, probably to escape the scandal of their affair in Ireland. He resigned his commission. She had been married to Gen. Sir William Forbes Gatacre but left the general and her two children to marry Fitzgerald. She died five years later. Their choice of Duarte may have represented a search for a more salubrious climate for her medical condition.

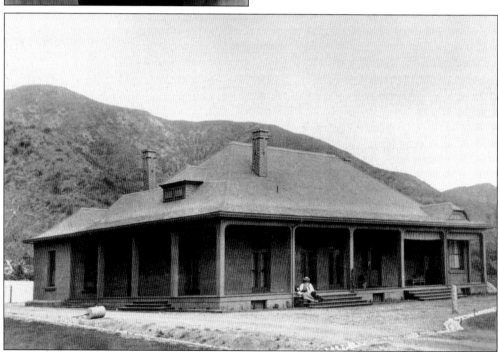

Mount Olivet was a grand house, built of reinforced concrete in 1892–1893 by Captain Fitzgerald. It had rare wood paneling, 12 rooms, 3 baths, servants' quarters, bungalows and other buildings, extensive gardens, and groves. Fitzgerald was said to have spent $200,000 on improvements of the 100 acres they had purchased from Eugene Meyers. Here it is when newly built.

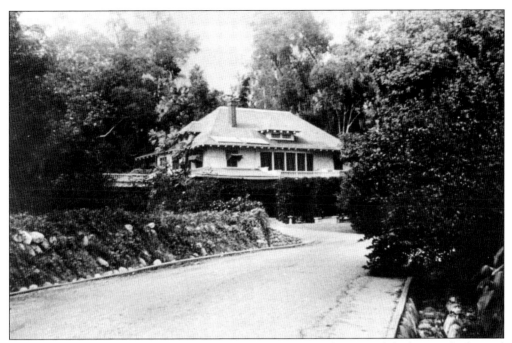

William Baird, a later owner of Mount Olivet, added a second story with bedrooms, baths, and handsome porte-cochere. It is shown here in the 1930s.

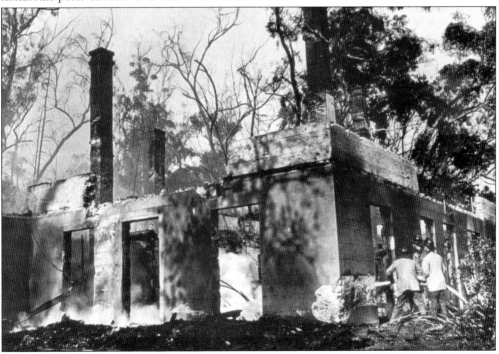

A fire on August 25, 1952, destroyed Mount Olivet in minutes, leaving only the ruins of the first floor and the four chimneys. The fire was caused by two boys playing with matches nearby. After the fire, the property was subdivided. Fifty-two homes were built, plus Royal Oaks School. Mount Olivet gave its name to Mount Olive Drive.

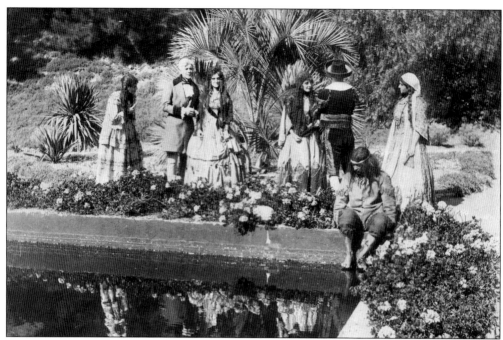

In 1916, the 10-reel full-length feature film *The Daughter of the Don* was filmed by the Monrovia Feature Film Group at Mount Olivet, then owned by William Baird. This still is one of the few known images from the film. The director, Henry Kabierske, was a noted director of pageants and directed the first presentation of the Mission Play in the new Mission Playhouse in San Gabriel.

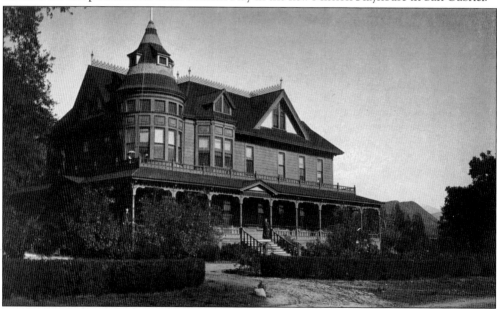

This major structure was built as a 28-room hotel, the Oaks, on north Highland Avenue, in anticipation of a substantial tourist business, perhaps upon the completion of the Southern Pacific line to Duarte. The boom never materialized, and it was sold to the Meredith and Gerhart families as a home for both of them. The property had 20 acres of oranges, lemons, grapefruit, and other fruits.

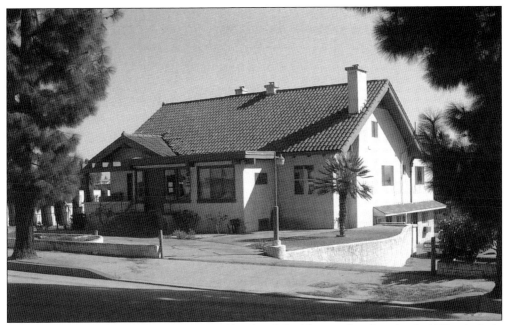

Noted architect John C. Austin constructed landmark buildings in Los Angeles. In 1910, relatively early in his career, he built a house for the E. B. Radebaugh family in Duarte. The family occupied it until the mid-1930s. It then became a sanitarium and later, for decades, the Evergreen Motel. It was located east of city hall on Huntington Drive and was demolished in 2007. This photograph was taken about 2005.

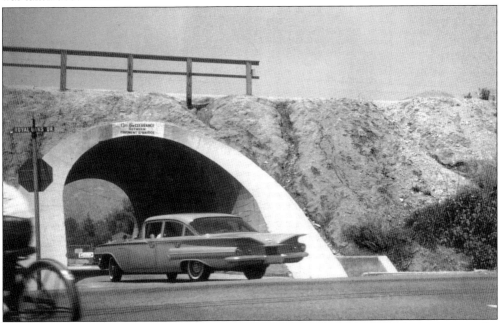

To carry its tracks at a relatively constant grade, the Pacific Electric required a bridge over the cut at Oak Avenue and an embankment at the lower elevation at Buena Vista Street. The embankment itself required a tunnel for vehicles and pedestrians. The embankment was removed after the PE went out of service.

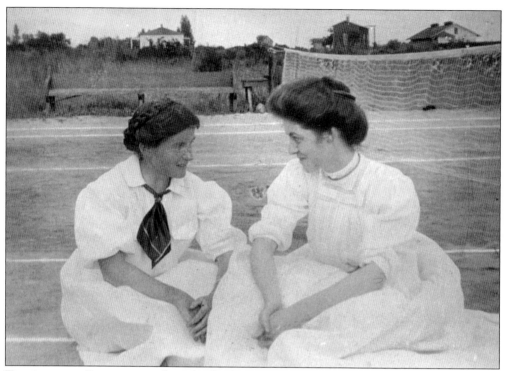

Tennis came to Duarte very early in the development of the lawn tennis game. About 1900, there were courts on Highland Avenue that were used by the social elite. Alice Scott (left) and May Dunn are at the Scott Tennis Courts at the Scotts' Hillside Ranch. Alice Scott was a winner of many singles matches and with several partners won many doubles competitions.

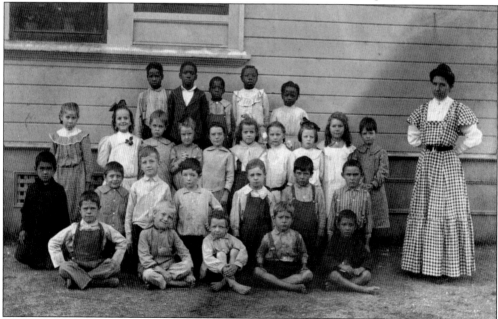

Caroline Carter, a long-term teacher at the Duarte School, stands next to her class in October 1907.

The Duarte Double Quartet is singing on the front steps of the Second Duarte School at a local rally for perennial (and unsuccessful) presidential candidate William Jennings Bryan, also of Scopes trial fame. From left to right are (first row) Leon Haydock, Ned Wardell, and Dick Wardell; (second row) Clarence Wardell, Jimmy Rogers, John Rogers, Will Rogers, and Lou Rogers.

Graduation Exercises

of the

Duarte Public School

June Fifteenth

Nineteen Hundred and Eight

———— • •• • ————

CLASS ROLL

MYRTLE V. AYRES
CYRIL O. CARTER
LAURA CHAPPELOW
FLORENCE PRICE
HARVEY L. ROY
CHESTER E. WILSON

CLASS COLORS
PINK AND WHITE

"Laugh and the world laughs with you,
Knock and you knock alone;
The man with a grin will always win,
Where the knocker is never known"

No matter how small the graduating class, frequently fewer than six students, the program for the graduation at the Duarte School was printed in elegant, formal style. Students performed recitations, poetry, plays, and musical numbers. This program is for the graduation exercises of June 15, 1908, at the Second Duarte School.

PART I	
Song — "Happy Greeting to All"	School
Welcome	Myrtle Ayres
Motion Song	First and Second Grades
Class Exercise; "A High Ambition"	Third and Fourth Grade Boys
Class Recitation; "The Seven Days"	Seven Primary Girls
Song — "See the Sun's First Gleam"	Fifth and Sixth Grades
Vacation Plans	Third and Fourth Grades
Recitaton: "The Doodle Bugs' Charm"	Rowena Shepard / Frances Bliss
Solo — "The Babes in the Woods"	Ada Newell
Recitation; "A Boy's Experience"	Harold Brown
Solo — "Little Bo-Peep"	Doris Downe

PART II	
Recitation; "Old, Old Lady"	Ada Newell
Song — "Jingle Bells"	Fith and Sixth Grades
Description; "Eagle Isle"	Florence Price
Recitation; "Johnnie Visits the Dime Museum"	Harvey Roy
Essay; "Locomotion"	Cyril Carter
Class Prophecy	Laura Chappelow
Oration; "The New Boy"	Chester Wilson
Address and Presention of Diplomas	MARK KEPPLE, County Superintendent
Remarks	Trustees
Song — "Good Night"	Girls Chorus

Four

HEALTH AND HIGH WATER

Even the excitement of World War I (1914–1918) seemed to do little to disturb the slowly growing community's placid and unhurried pace. Civic organizations such as 4-H and a Reading Circle were in place, but even as late as 1934, the Duarte Post Office had only two employees to serve 200 to 300 residents. It was located to the rear of the building on our cover, the southwest corner of Highland Avenue and Royal Oaks Drive. The mail arrived either by a Model T Ford twice daily from the Santa Fe Railway to the south or via the Pacific Electric stop at Oak Street.

Meanwhile, Duarte's eventual reputation as a "City of Health" had been reinforced with the arrival of the Carmelite Sisters in 1930. These devoted servants followed in the footsteps of the earlier National Jewish Consumption Relief Association's establishment along Duarte Road in 1913. Santa Teresita Hospital and the nationally known City of Hope grew out of these early efforts. An interesting subtext to this well-known story connects to the realm of art and culture. Professional wood carvings at Santa Teresita and a fine Mannerist painting at the City of Hope Visitor's Center epitomize the holistic contribution these institutions were making as the 1930s led into the 1940s.

Then came disaster.

Secure access to water supplies is integral to the California story, and Duarte was no exception. But enough is enough—even of water! A torrential downpour was responsible for the otherwise stable Duarte's one bona fide natural disaster. This occurred in 1938 when a record-level rainstorm deluged the entire Los Angeles Basin and did permanent damage to the Puenta Largo Aero Bridge, spanning the San Gabriel River. The bridge had served the community since 1907. Repairs were urgently needed and made. The busy life of watching for early frosts and lighting smudge pots continued. In 1941, civic organizers celebrated the old rancho's centennial with its one and only historical pageant. Communitarian resilience carried the Queen Colony forward to World War II even as new transportation dynamics tracing to the automobile were setting the stage for dramatic changes.

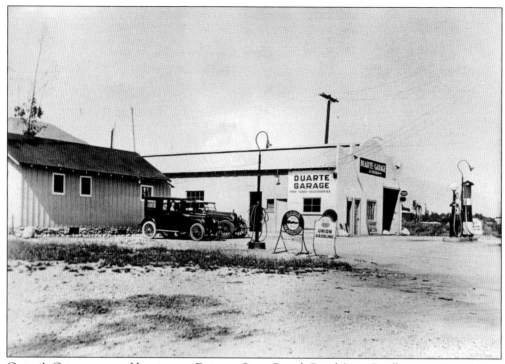

Georgi's Garage was on Huntington Drive at Scott Ranch Road (now Bradbourne Avenue).

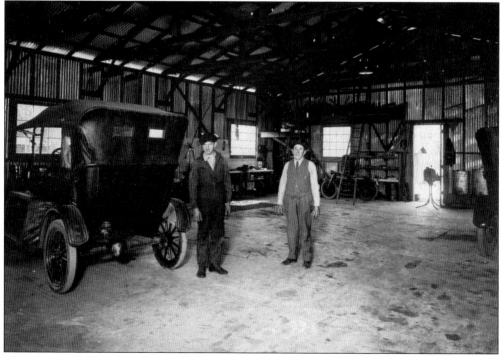

John Strunz (left) and his cousin A. Georgi are inside Georgi's Garage. This photograph was taken about 1929. Strunz, a mechanic, was a major benefactor of the Duarte Historical Society, leaving to it the greater part of his estate.

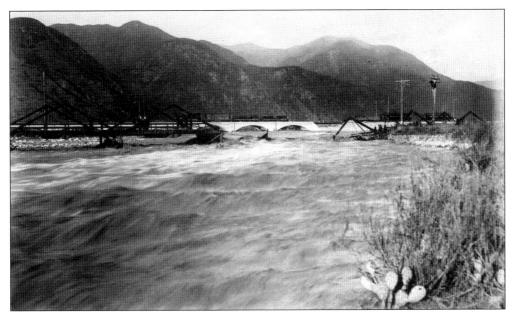

Periodic floods have washed away several bridges over the San Gabriel River and have damaged others. The Puente Largo Aero bridge, built to carry the Pacific Electric and the Southern Pacific over the river, has been seriously damaged twice. This photograph is of the 1914 flood that damaged both the railroad and the nearby highway bridge. Decades later, levees were constructed to contain the high waters that occasionally follow heavy rains. (Courtesy Glendora Historical Society.)

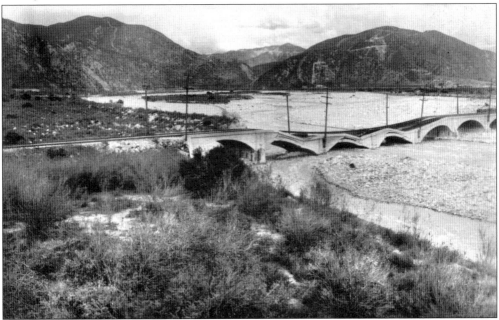

In March 1938, a normal year's worth of rain fell in just four days. The Morris and San Gabriel flood control reservoirs on the San Gabriel River were full, and their overflows caused great destruction downstream. Three piers of the Puente Largo Aero Bridge were undermined, and four arches collapsed. The arches were replaced by steel spans that permitted rail service to continue. Bicyclists and pedestrians now use the bridge. (Courtesy Lois Spielman.)

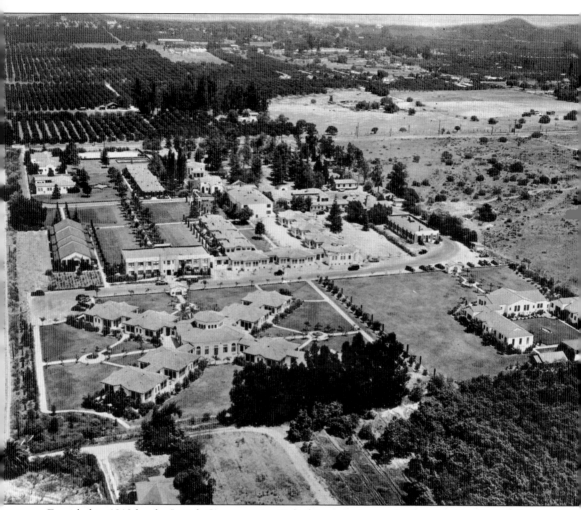

Founded in 1913 by the Jewish Consumptive Relief Association as the Los Angeles Sanatorium, City of Hope was originally formed to treat tuberculosis patients. This view of City of Hope's campus in the 1940s looks north toward the San Gabriel Mountains. Here before the Medical Center was built, Morris Hillquit Memorial Hospital can be seen in the foreground while in the center of the photograph (from left to right) are the Philadelphia, Warner, Pressman, and DeVorkin Buildings. In 1946, the institution launched an ambitious plan to transform itself into a national medical center, supported by a research institute and postgraduate education. Today City of Hope comprises an innovative Medical Center, an NCI Comprehensive Cancer Center, the Beckman Research Institute, and programs in graduate, clinical, and postdoctoral training. The Pacific Electric railway line and the parallel Duarte Road run from left to right. (Courtesy City of Hope Archives.)

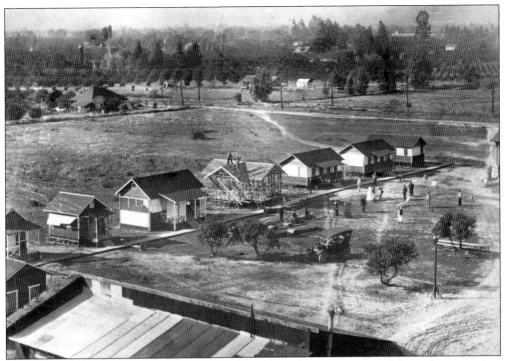

This view of City of Hope buildings looks northwest from the water tower and shows the sanatorium in 1914 or 1915. (Courtesy City of Hope Archives.)

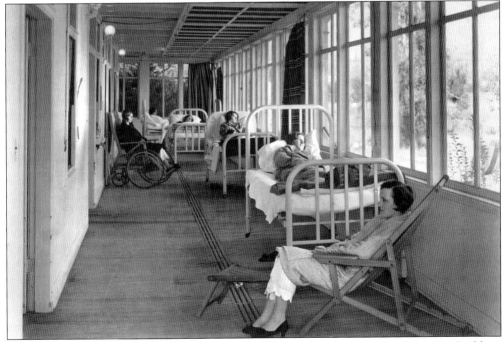

The City of Hope's Women's Pavilion in the early 1930s was located in the San Francisco Building. It allowed patients access to sunshine and fresh air. Treatment for tuberculosis also included rest and healthy food. (Courtesy City of Hope Archives.)

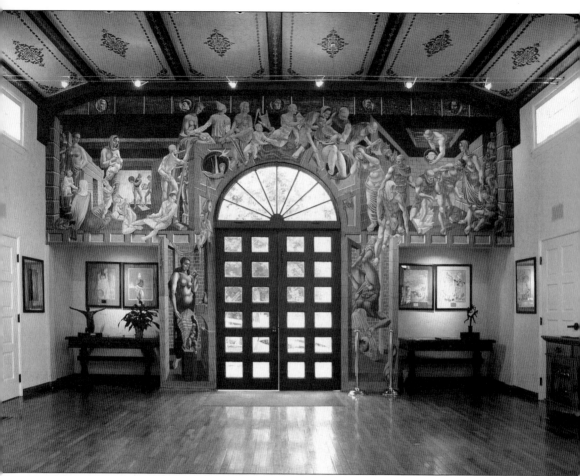

In 1935, Philip Goldstein (later known as Philip Guston) and Reuben Kadish, as part of the Federal Art Project established under Pres. Franklin D. Roosevelt's New Deal, created a fresco entitled *The Progress of Life*. They spent close to a year creating the Mannerist-style mural. In 1998, it was restored with assistance from the Getty Conservation Institute. It is now viewable as originally intended in what has become the Visitor's Center. (Courtesy City of Hope Archives.)

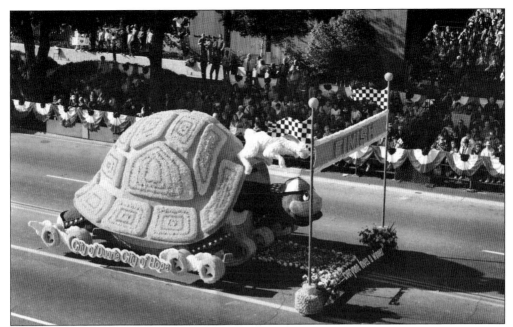

Since 1973, the City of Hope and the City of Duarte have joined forces to create a float for the annual Rose Parade in Pasadena. They won first place in their division from 1973 to 1980. The 1985 float, "The Spirit of America," is shown here, with the theme of the tortoise and the hare. (Courtesy City of Duarte.)

By 1945, the business of the Duarte Post Office has increased enough to begin local delivery. Mail carrier Bullock (left) is meeting with postmaster Thomas V. (Tommy) Holmes. Holmes served in that position from 1934 to 1966, the longest term of any Duarte postmaster, longer than Joe Fowler's 30 years.

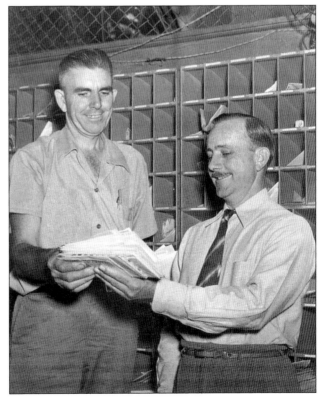

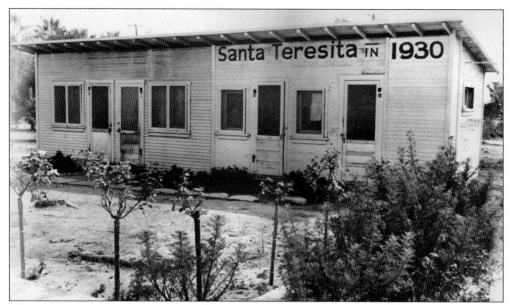

The Carmelite Sisters, having gained permission to open a sanitarium for girls and women afflicted with tuberculosis, bought 3 acres of land in Duarte, a former orange grove. Their first patient dormitory in 1930 was this small building, fondly remembered as the "chicken coop." A garage served as the recreation room. Eleven more acres and many buildings and facilities were added over the decades. (Courtesy Santa Teresita Medical Center.)

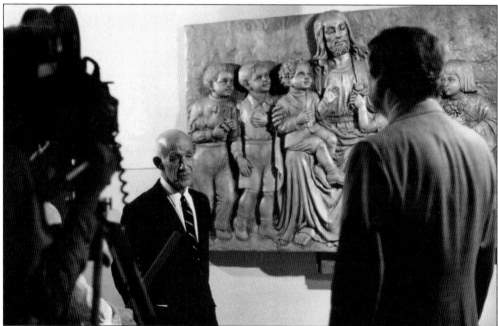

Rudolph Vargas, a professional wood carver born in Mexico in 1904, created works for many clients. His religious works were created in a Renaissance style, and he left many of them at Santa Teresita. Some of them were supported by donations while others were donated by the sculptor himself. Here Vargas is shown during a television interview. (Courtesy Santa Teresita Medical Center.)

Mother Margarita Maria was the founder of Santa Teresita and was its driving force from 1930 until her retirement in 1988. (Courtesy Santa Teresita Medical Center.)

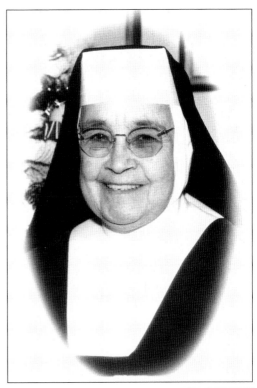

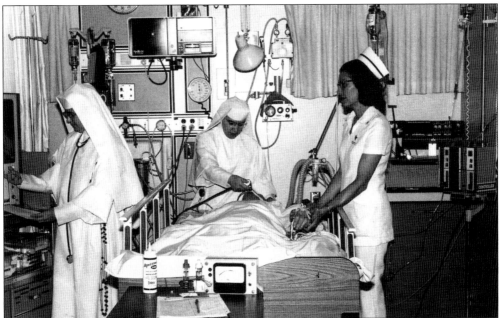

Santa Teresita became a full acute-care hospital by the late 1970s. Its fully equipped intensive care room offered professional treatment. The nurses are, from left to right, Sister Imelda Marie, OCD, RN; Sister Virginia Therese, OCD, LVN; and Awilda Porter, RN. In 2004, reflecting the increasing demands on acute-care hospitals, it refocused as a provider of outpatient services and a 133-bed skilled nursing facility. (Courtesy Santa Teresita Medical Center.)

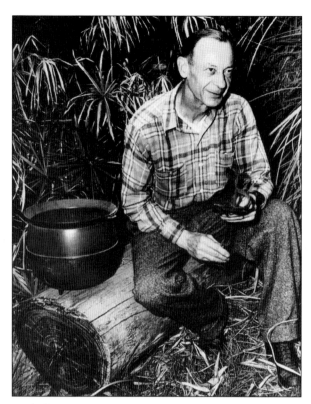

Leslie Carman holds Andres Duarte's branding iron and cast-iron bean pot. The branding iron is on display in Duarte City Hall. Carman played both William Wolfskill and Will Beardslee in the 1941 Duarte Historical Pageant.

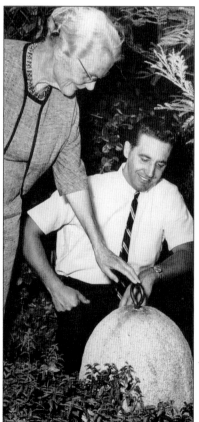

Ida May Shrode and Alden Beckett inspect an early hitching post. Beckett was a member of the Duarte City Planning Commission in 1963–1964.

Five

LIFE ALONG THE
MOTHER ROAD

What John Steinbeck proclaimed as America's "Mother Road"—the 2,450 serpentine miles of U.S. 66, begun in 1926—was a godsend for farmers and small-town producers in the American interior. Duarte was no exception. Route 66 went through the city along Duarte's Huntington Drive. Duarte's first traffic light came in 1957 at the intersection of Huntington Drive and Los Lomas Road.

The career of John Strunz, a mechanic, was typical of developments in this period. Operating a garage, he prospered enough to leave an endowment to the Duarte Historical Society, which has named a museum room—the Strunz Memorial Room—in his honor. He capped a life of civic involvement by being named grand marshal of Duarte's Bicentennial Parade in 1976.

By 1950, the Justice brothers from Kansas—Ed, Zeke, and Gus—had relocated in California to establish a major automotive car-care business. That year, their entry in the Indianapolis 500 won first place, launching a long winning streak over the next decades. Their move to Duarte in 1985 gave the city one of the premier automobile museums on the West Coast.

Mostly, however, Duarte at mid-century and beyond was transformed by the arrival of hundreds of eager young men returning from World War II, anxious to start new families and enjoy the quiet life in a suburb that only recently had been orange and avocado groves. As shown in chapter five, famed bandleader Glenn Miller had built a house here during the war on Bettyhill Road and planned to return to his ranch house after the fighting stopped. The Duarte Historical Museum offers many enlightening artifacts from Miller's illustrious career. As the new generation switched their radio dials from Tuxedo Junction to rock n' roll, Duarte plugged along, beginning its transition from a bastion of the citrus industry to the commuter and bedroom community it is today. In 1965, the Duarte Chamber of Commerce was invited to the ground-breaking for the new Foothill Freeway. Change was coming, and Duarte would learn to adjust to the new realities.

The Trails Restaurant, opened in 1950, was once a noteworthy Duarte landmark along U.S. Route 66. Its loyal patrons remember a wide variety of food and lively sing-alongs that made it an affordable and popular Duarte attraction, emblematic of the spirit of Route 66. It was torn down in 2002 but not without an upsurge of spirited protests from its devotees. (Courtesy the Route 66 Corridor Preservation Program, National Park Service.)

After Mount Olivet burned, the land was redeveloped with housing and the Royal Oaks School. At the school's ground-breaking were, from left to right, (first row) John Scott Meier and Susan Meier; (second row) R. A. Crowell, contractor; Maynard Lyndon, architect; Herbert J. Meier; Margaret Scott Meier; Hazel Nelson; Maylon Drake; and Albert Welton.

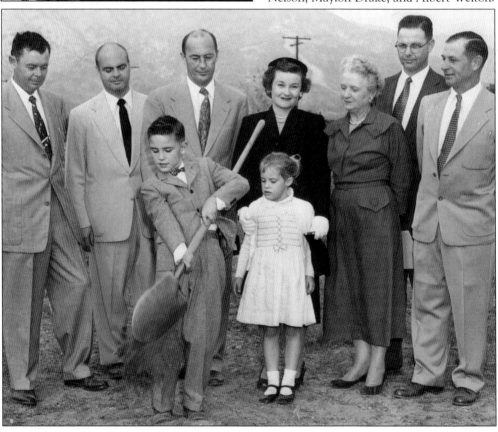

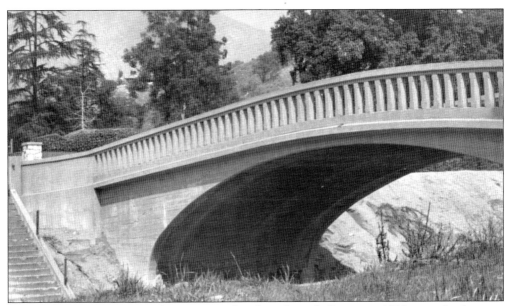

Construction of the Pacific Electric interurban line through Duarte in 1908 created a deep cut south of the Bradbury estate. The Bradbury family and the PE built a single-arch reinforced concrete bridge to restore access from the south. The bridge is now used only by pedestrians. After nearly a century, it was jointly renovated by the Cities of Duarte and Bradbury. The PE's rolling stock was painted red, so its cars were called the Red Cars.

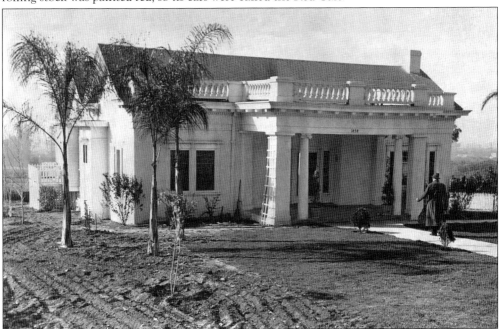

This house is now the Duarte Historical Museum but is shown at an earlier location 2 miles west, where the Mormon church now stands. Los Angeles district attorney Buron Fitts owned the house. His father, Buff Fitts, is shown walking up the path in 1937. The Duarte Historical Society acquired the house in 1991 and moved it to its present location and use in Encanto Park. (Courtesy Herald Examiner Collection, Los Angeles Public Library.)

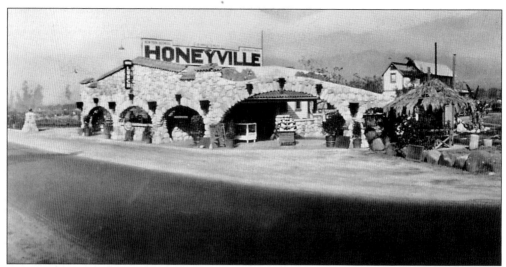

Honeyville was a roadside food-and-drink stop that also sold the Mayer family's honey production. Like many other roadside enterprises, it displayed the distance to important places: Los Angeles, New York, and London, England.

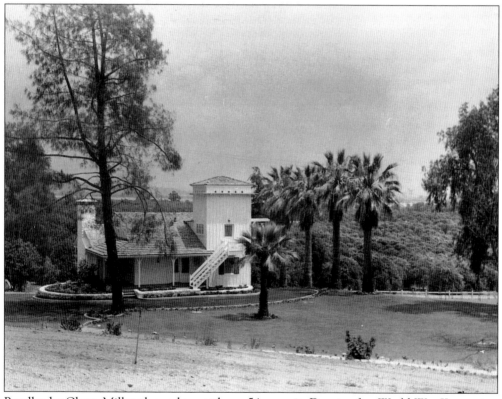

Bandleader Glenn Miller planned to settle on 54 acres in Duarte after World War II, growing citrus fruit for half the year and touring the other half. However, he died in an airplane accident before the war ended, leaving the house to his wife and children. This was a ranch house, a place for his musicians and the family to use until a permanent home could be built. It was destroyed in 1980 by a wildfire.

This personally autographed picture of Glenn Miller was donated to the Duarte Historical Museum by Miller's daughter Jonnie in 2001. A display case in the museum contains papers, photographs, recordings in various media, and other mementos of Glenn Miller. (Courtesy Jonnie D. Miller.)

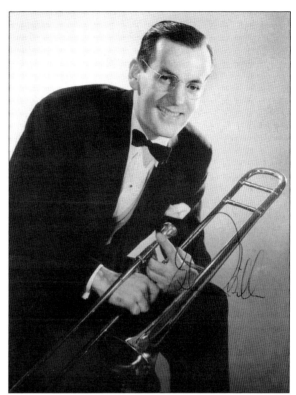

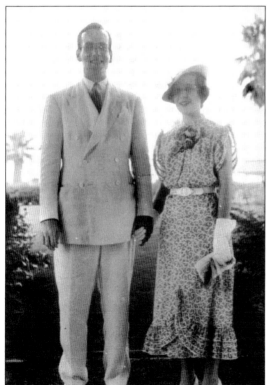

At the 2001 dedication of the bronze historical plaque commemorating Glenn Miller's association with Duarte, his daughter presented the historical society with this photograph of her parents, Glenn and Helen Miller. (Courtesy Jonnie D. Miller.)

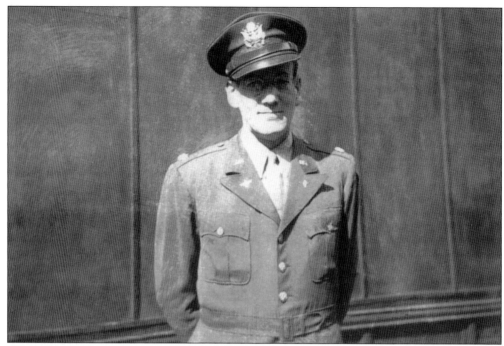

When the historical marker remembering Glenn Miller in Duarte was dedicated, Tony Gervasi, a local resident, donated this picture. He was a soldier carrying a camera on December 14, 1944, when he met Glenn Miller on the street in London during World War II. Miller agreed to pose. He disappeared the next day, his plane never reaching France. This is the last known picture of Glenn Miller. (Courtesy Tony Gervasi.)

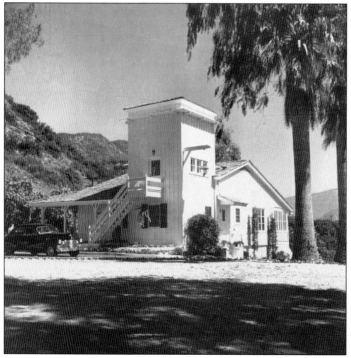

The Miller house was very close to the hills, along the northern border of the original Duarte rancho. All ranchos excluded the mountainous lands but generally their boundaries started at the base of the hills, making them susceptible to wildfires. The lawn had not yet been planted. The front door to the house was on the north side. The door shown (with the overhang) was the back door to the kitchen. (© 2009 Steven D. Miller, all rights reserved.)

Miller's garage was much larger than a single family would need, as the house was intended, at least temporarily, as a place for the Miller orchestra to gather. With technology somewhat in advance of its time, both garage doors were electrically operated, though they lacked today's remotes. There were switch buttons inside the garage and also on two posts on the driveway away from the house. (© 2009 Steven D. Miller, all rights reserved.)

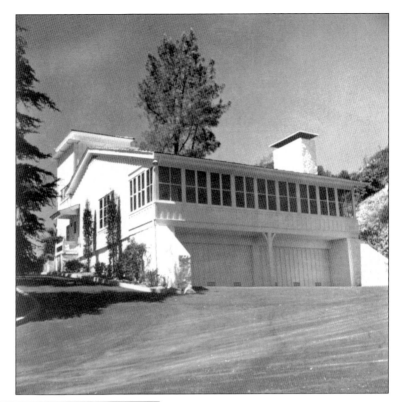

This view is from the landing on the tower bedroom of Glenn Miller's house. It looks to the southeast and shows the orange groves on the ranch, the neighbor's ranch, and the avocado trees that had just been planted. The dirt road to the left of the avocados was the neighbor's access. (© 2009 Steven D. Miller, all rights reserved.)

Dr. Wayland A. Morrison owned the ranch in Duarte that was first purchased by his father, Dr. Norman Morrison. Wayland Morrison became the chief medical officer of the Santa Fe Railway. Norman Morrison did not build a permanent house on the property in Duarte; his son Wayland did. Lucile Phillips Morrison, Wayland's wife, was especially active in civic activities in Duarte.

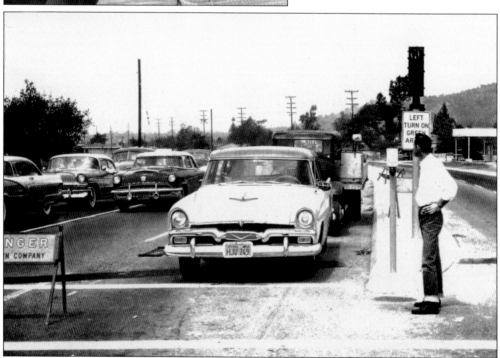

As a sign of the times, with increasing automobile traffic, controls came to Duarte in 1957 with the installation of the first traffic light, on Huntington Drive at Las Lomas Road.

Six

BUILDING THE DREAM

Between 1975 and 1985, some 2,000 new homes were built in Duarte. More than 70 percent of the housing stock in today's Duarte was built before 1980, mostly single-family dwellings. The old Pacific Electric tracks were removed, and in 1975, a 1.6-mile, largely landscaped recreational and hiking trail took its place. In 1976, patriotic Duarteans celebrated America's bicentennial with a lively parade along a still-undivided Huntington Drive.

In these years, the City of Duarte entered a fresh growth spurt that shaped much of the urban environment we see about us today. The 210 Freeway had reached the area in 1968, putting an end to most of the close-knit communal life of independent homeowners in the area known as Rocktown. In 1977, the Lewis Industrial Park, the city's first redevelopment project, east of the City of Hope, was opened, finally ending the last traces of the old Davis Addition. In 1982 came the Duarte City Center Complex, edging out the west section of the Alpha Beta shopping center, which an earlier generation would have recognized. The 1980s ushered in an era of steady commercial growth that has continued. A city population of 10,000 in 1976 was on its way to today's 22,000.

This transition was building on the well-laid, forward-looking trajectory that had been set in earlier years. The commitment to culture and education endured among those civic leaders who had led the community at mid-century. The first free-standing Duarte Library opened in 1950 at the Morrison family's Rose Cottage on Santo Domingo Avenue. It moved to Brycedale Avenue and Huntington Drive before opening in its present 10,000-square-foot complex on Buena Vista Street in 1966. Still, city activist Aloysia Moore wrote nostalgically in 1976 of an era that had passed as one dream gave way to another: "Almost overnight, it seemed, we had changed from a rural community to a residential city."

Rancho Azusa de Duarte
Historical Pageant

Written by
Mr. and Mrs. E. B. Norman

Song words written by
Rosamond Norman

Play directed by
Thelma Laird Schultheis

Mrs. Mary Rogers, assistant director

Mrs. Seymour Blain, Chairman

Friday, May 9, 1941
Duarte School

Once and only once, the Duarte community has arisen to produce a Duarte Historical Pageant, reenacting the acquisition, events, and loss of the rancho, the personalities of the major players in these events, and the influx of later settlers. It was presented in May 1941, at the Third Duarte School, 100 years after the land grant. The libretto by Rosamond Norman was set to popular tunes. Descendants of people prominent in Duarte history were participants in the pageant, and some played themselves or family members. Rosamond Norman was also the writer of the Duarte city song.

Scene 1
Don Felipe Carrillo.....................Courtland Elliott
Senora Carrillo.........................Mrs. J. H. Shrode
Don Andres Duarte.......................H. K. Pritchard
Senora Vallijo...............Mrs. Beatrice Duarte Cuellar
Agrapina................................Phyllis Cuellar
Petronila...............................Geraldine Cuellar

Scene 2
Don Andres Duarte......................H. K. Pritchard
Senora DuarteMrs. W.W. Bacon
Don Felipe Carrillo....................Courtland Elliott

Scene 3
Senor Duarte..........................H. K. Pritchard
Senora Duarte.........................Mrs. W.W. Bacon
Young Lady visitors.....................Ruth Chappelow
 Lois Beardslee
Jose...................................David Carman
Indians............Charles Nickels, Stanley Kennedy
 John Kinne, Howard Biggers
Children.............Edward Macken, Barbara Cuellar

Scene 4
Senor Duarte's Household and Friends

Scene 5
Senor Felipe Duarte...................Manuel Guttierrez
Senorita Maria LopezMiss Georgette Schaller

Scene 6
Senor Duarte's Household and others Dancers....
 El Recuerdo, Dancing Club
Scene 7
Maria.............................Miss Georgette Schaller
Little JoJohn Cuellar
Senor DuarteH. K. Pritchard

Scene 8
Senor DuarteH. K. Pritchard
Maria.............................Miss Georgette Schaller
1st Man..................................A. D. Welton
2nd Man..................................J. A. Blain
3rd Man.................................Herbert Smith

Scene 9
Auctioneer Sanchez........................M. L. Clark
William Woolfskill.......................Leslie Carman

Scene 10
Maj. Shrode, Blacksmith.................Herbert Smith
Frank Ellis...............................J. A. Blain
A. T. Caldwell...........................A. D. Welton
Captain Fowler...........................Joe Fowler
Thomas Wardall........................Seymour Blain
Frank Graves.............................Guy Dickey
Emmett Norman.......................Emmett Norman
Will Beardslee..........................Leslie Carman
Sam Maxwell.............................Tom Butcher
Albert Beall..........................Earl Richardson

The cast of the May 9, 1941, pageant included Beatrice Duarte Cuellar, great-great-granddaughter of Andres Duarte, and her daughters (from left to right) Phyllis, Geraldine, and Barbara.

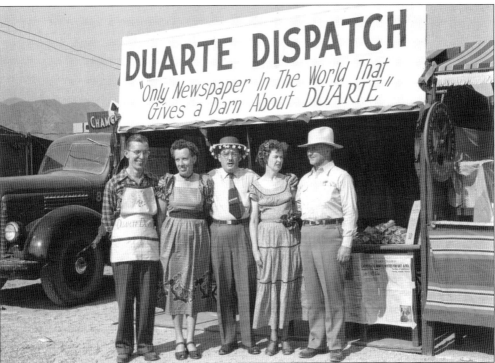

A local newspaper was considered desirable, another sign of progress. Lovell Fulbright took over about August 1966 as the editor of the *Duarte Dispatch*, which began publishing several years earlier. Its very modest slogan is shown on the sign and was carried on the front page of the newspaper itself. From left to right are Lovell Fulbright; Mamie Fulbright; D. J. Smith, owner of the *Dispatch*; and Mary Lou and Bill Atkinson.

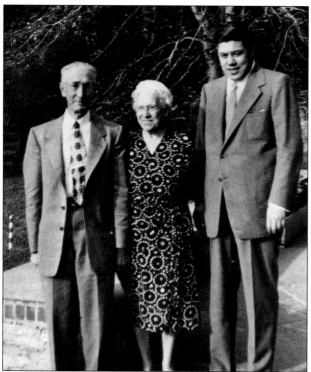

Frank Hsu, a successful importer-exporter, was educated in China by missionaries. Finding his retired mentor William C. Booth and his wife in poor circumstances, he contributed $1 million to found a proper home for retired Presbyterian missionaries. Those funds made possible the purchase of the Morrison ranch in Duarte to establish Westminster Gardens and provided an endowment. Building began in 1950 to create housing for residents. (Courtesy Westminster Gardens.)

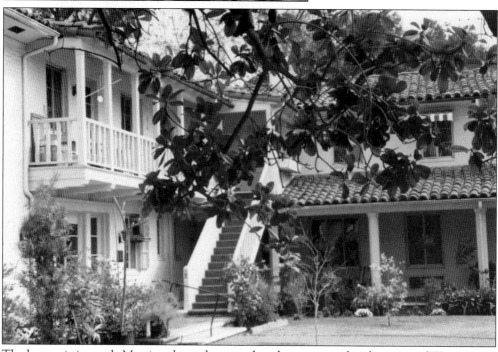

The large mission-style Morrison home became the administrative headquarters of Westminster Gardens and continues in that function to this day. It was originally designed to provide individual apartments for Dr. Wayland Morrison; his wife, Lucile; and each of their five children. (Courtesy Westminster Gardens.)

In 1950, the local chapter of the American Friends Service Committee organized efforts to help rebuild and repair buildings in Rocktown. Dozens of volunteers from many states participated in the effort. The AME church was elegantly restored and reopened with a great celebration.

The American Friends Service group worked on projects other than the local church. The volunteer workers are shown here at a private house.

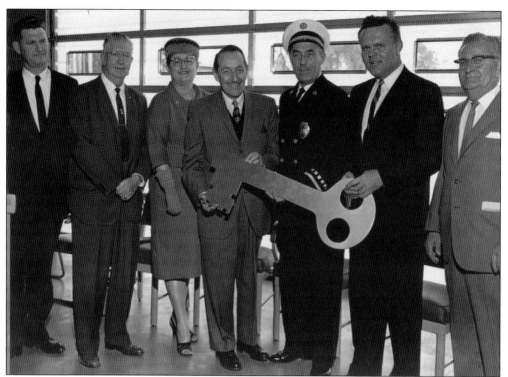

In 1965, the new Los Angeles County Fire Station No. 44 was dedicated on Highland Avenue in Duarte. It was also designated a "watershed" station, which signifies that the firefighters are trained to fight fires not only in the urban areas but also in the watershed in the hills above the city.

As population increased following World War II, Duarte citizens felt it desirable to have a Community Services Council to discuss and coordinate approaches to problems. Organizers were some of the same people who had led home front activities during World War II. Here the council is meeting in the early 1950s.

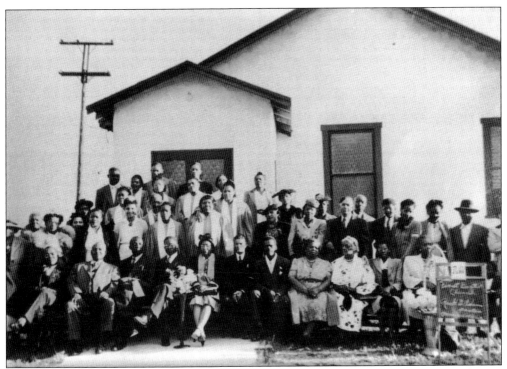

The First Baptist Church of Duarte moved from Rocktown in 1948, but this picture depicts the congregation as it was in 1944 or 1945 on the historic Davis Addition. First Baptist Church celebrated its 125th anniversary as a gathered community in February 2009. (Courtesy First Baptist Church of Duarte.)

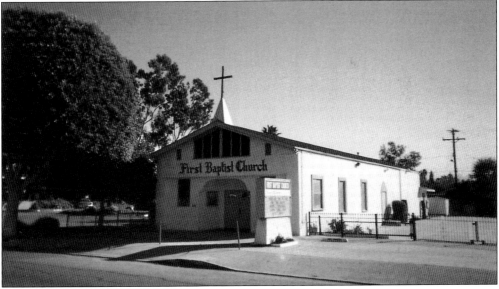

The First Baptist Church, at 2200 Huntington Drive, remains a center of lively congregational worship. It was refurbished from 1976 to 1978. The congregation itself represents an organizational legacy from the old Davis Addition or Rocktown. A cornerstone marker states that the church was organized in 1924 and moved to its present location in 1948. (Courtesy Neil Earle.)

William H. Lancaster was instrumental in the incorporation of the city of Duarte. First elected to the Duarte City Council in 1958, he served three terms as mayor before election to the California State Assembly in 1972. On the Assembly Committee on Transportation, he fought for extending the Foothill 210 Freeway and access ramps to and from Duarte. The local portion of the 210 Freeway is named for him. He was 1991 Legislator of the Year of the League of California Cities. (Courtesy City of Duarte.)

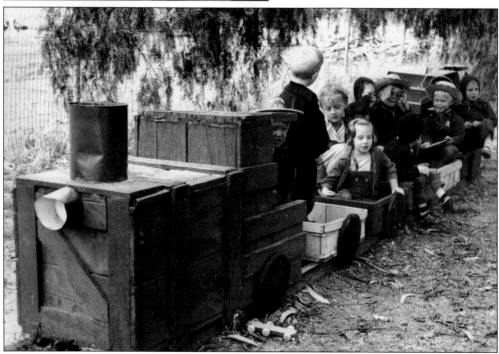

Newsletters have appeared over the years in Duarte under various names. This picture from a 1951 newsletter shows a picturesque toy train that obviously excited the small children who were privileged to ride in it.

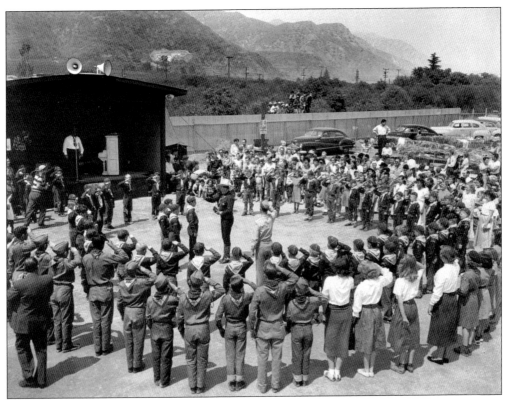

Conceived of as a way of promoting civic spirit, the Fiesta de Duarte ran for years during the 1940s and 1950s. Annually thousands of people attended the fiesta, which lasted for several days and provided both exhibits and food for visitors. It was held in Swiss Park, a private facility whose name now remains as Swiss Park Drive.

For the 1955 Fiesta de Duarte, there was this program, promising something for everybody: "Dancing! Eating! Horses! Music! Races and contests. Entertainment for two days."

LA FIESTA DE DUARTE
Program of Events
SWISS PARK — JUNE 11 & 12

SATURDAY, JUNE 11, 1955

9:00 a.m. Free Hotcake and Sausage Breakfast

9:15 a.m. Judging of All Exhibits
Official Opening 114th Anniversary La Fiesta de Duarte.
Parade of Color Guards and Flag Ceremony. Opening greetings—Dave Jackson, Grand Marshal and Duane Wright General Chairman.

11:15 a.m. Concert—Duarte All-City Band, directed by John Linfors.

12:00 noon Children's races and contests.

2:30 p.m. Square Dancing, Andres Duarte School

3:00 p.m. Entrance of Wrangler Jim and his favorite horse, Cochise.

5:00 p.m. Melody Makers — Cowboy Band

8:00 p.m. Dancing—music by Phil Webber and His Rhythm Rockers.

9:00 p.m. Demonstration of Latin-type ballroom dances, Tommilea Patrick, Tefan Kent and Doyle Chadwick of the Arthur Murray Studio.

10:00 p.m. Dancing

SUNDAY, JUNE 12, 1955

12:00 noon Spanish Beef Barbecue Dinner

2:00 p.m. Lyric Accordion Band

3:00 p.m. Lily Aguilar Dancers—Spanish dances

4:15 p.m. Second part Lily Aguilar Dancers

Evening Entertainment Will Be Announced Later

The tug-of-war does not look to be very taxing. But the amusement level was high.

The 1955 Fiesta de Duarte included performers such as this anonymous señorita, suitably attired for the occasion.

Thousands of visitors were reported to have eaten the foods prepared for the 1955 Fiesta. Probably few exhibited more enthusiasm than these.

The northeast corner of the Morrison ranch along Huntington Drive became a recreation area known as Duarte Youth Acres. It was dedicated on June 1, 1950, with ceremonies involving local residents and Boy Scouts.

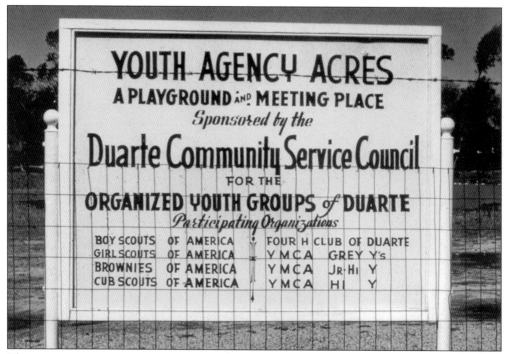

This sign presents a summary of the organizations that supported Duarte Youth Acres and of the umbrella organization, the Duarte Community Service Council.

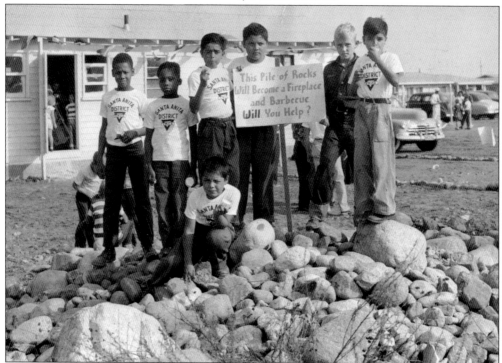

A pile of rocks, intended for a barbecue or fireplace, stands as an invitation to the public to contribute to the building of recreational facilities in Duarte.

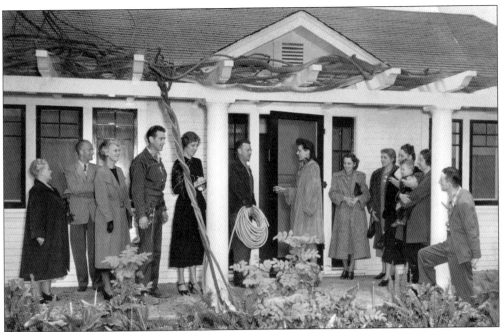

The Morrisons created Duarte's first health and welfare center in a former groundsman's cottage decorated with children's story motifs. Present at the March 6, 1950, dedication were, from left to right, Marguerite Evans; Charles H. Over; Marguerite Maxwell Lloyd; George Bunnell, electrician; Lucile Morrison; Chet Deming, electrical contractor; Grace Nelson, L. A. County district nurse; Lillian Forden; Mrs. Foster; Jeanne Abouchar; Richard A. Moore III (toddler); R. Aloysia Moore; and Lovell Fulbright.

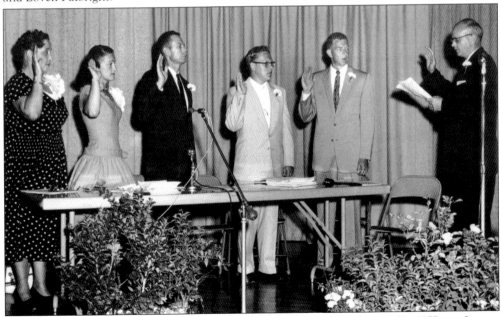

From left to right, being sworn in as Duarte's first city council on August 22, 1957, are Jeanne Abouchar, Vera M. Hacker, Walter C. Hendrix, John E. K. Lindfors, and Robert K. Swain, with Judge John Sturgeon of the Santa Anita Municipal Court presiding. (Courtesy City of Duarte.)

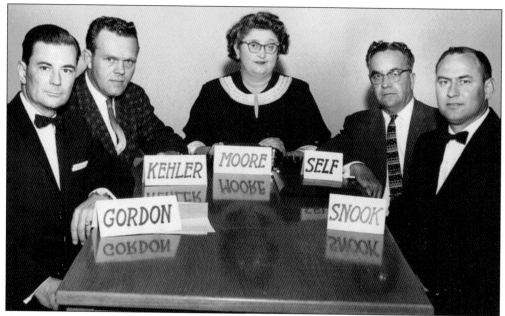

Otis Gordon (left) was active in the 1957 campaign that opposed annexation of Duarte, then unincorporated, into Azusa. A Duarte park is named for him. Others in this meeting picture are Donald H. Kehler; R. Aloysia Moore; Homer Self; and Leland Snook. Moore was curator of the Duarte Historical Museum for years, and another park is named for her.

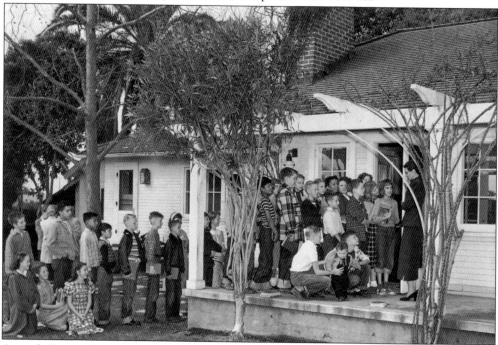

An early Duarte library had been housed in a local school building. In 1950, the Morrison family's Rose Cottage on Santo Domingo Avenue was the first free-standing Duarte branch of the county library. It opened to great local excitement on March 6, with crowds of adults and children. Lisa Pederson, the librarian, stands next to the door.

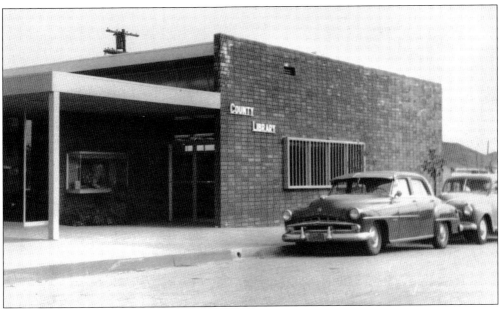

This building, still standing just south of the corner of Brycedale Avenue and Huntington Drive, served as the county library in Duarte after library use of the Morrisons' Rose Cottage was discontinued. It functioned until 1966, when the present branch of the county library was completed on Buena Vista Street.

The county library system created the present 10,000-square-foot Duarte library building on Buena Vista Street, completing the project in 1966. Laying the cornerstone in 1964 are, from left to right, Prentiss Ham, Mr. Thomas, Supt. Frank Bonelli, Artie Willett, R. Aloysia Moore, and Bill Geller.

DCTV host Mary Barrow interviews Duarte mayor Donald R. Watson, who in 1971 became the first African American mayor of a city in the San Gabriel Valley.

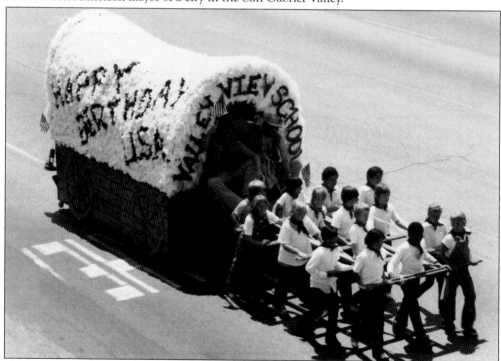

Children from Valley View School pull a wagon west on Huntington Drive on July 4, 1976, America's bicentennial. The wagon recalled an early means of transportation used by some of Duarte's early settlers from the South and Midwest, most notably Dr. Nehemiah Beardslee and his family's ox-drawn cart, which arrived here in 1861. (Courtesy Duarte Chamber of Commerce.)

Crowds attended the dedication of the new Duarte City Hall and Town Center Complex in July 1982. The dark wood-stained buildings reflect what has been called "Early California" architecture. The low-lying bungalow/adobe effect presents a blend of the early ranchos and Old California missions, evidenced by the water fountain in the left foreground. Facilities also include the City of Duarte Fitness Center, outdoor community swimming pool, Duarte Senior Center, and Duarte Unified School District. (Courtesy City of Duarte.)

In 1985, Justice Brothers, Inc., manufacturers and distributors of car-care products, moved to Duarte. It was founded by three brothers—Zeke, Ed, and Gus Justice—who sponsored first- and second-place finishers of the Indianapolis 500 beginning in 1950. At the Darlington 500 in 1950, they introduced the first race team uniforms in NASCAR. Here current CEO and president Ed Justice Jr. poses at the 2000 Indy 500 with uncle Zeke (center) and father, Ed Justice Sr. (Courtesy Justice Brothers Racing Museum.)

U.S. Supreme Court

BD. OF DIRS. OF ROTARY INT'L v. ROTARY CLUB, 481 U.S. 537 (1987)

481 U.S. 537

BOARD OF DIRECTORS OF ROTARY INTERNATIONAL ET AL. v. ROTARY CLUB OF DUARTE ET AL.

APPEAL FROM THE COURT OF APPEAL OF CALIFORNIA, SECOND APPELLATE DISTRICT

No. 86-421.

Argued March 30, 1987
Decided May 4, 1987

Rotary International is a nonprofit corporation composed of local Rotary Clubs. Its purposes are to provide humanitarian service, to encourage high ethical standards in all vocations, and to help build world peace and good will. Individuals are admitted to local club membership according to a "classification system" based on business, professional, and institutional activity in the community. Although women are permitted to attend meetings, give speeches, receive awards, and form auxiliary organizations, the Rotary constitution excludes women from membership. Because it had admitted women to active membership, the Duarte, California, Rotary Club's membership in the international organization was terminated. That club and two of its women members filed a suit alleging that the termination violated California's Unruh Act (Act), which entitles all persons, regardless of sex, to full and equal accommodations, advantages, facilities, privileges, and services in all business establishments in the State. The state trial court entered judgment for Rotary International, concluding that neither it nor the Duarte Club is a "business establishment" within the meaning of the Act. However, the State Court of Appeal reversed on this point, and rejected the contention that Rotary's policy of excluding women is protected by the First Amendment. Accordingly, the court ordered the Duarte Club's reinstatement, and enjoined the enforcement of the gender requirements against it.

In 1977, Duarte Rotary Club admitted Donna Bogart, Mary Lou Elliott, and Rosemary Freitag as members, contravening International's male-only rule. Rotary International revoked its charter. After years of litigation, in 1987, the U.S. Supreme Court, in *Board of Directors of Rotary International et al. v. Rotary Club of Duarte et al.*, affirmed that business-oriented service clubs could not exclude women. Duarte Rotary's initiative had established a new rule.

Celebrating the 20th anniversary of the Supreme Court decision are, from left to right, Christine Montan, Rotary district governor 5300; Mary Ann Lutz, assistant governor; Cecilia Arnerich, president Duarte Rotary 2006–2007; Carol Agate, ACLU's attorney in the lawsuit; Sanford K. Smith, Duarte Rotary's attorney; Lois Gaston, Duarte mayor 2006–2007; Shelan Joseph, ACLU; Luke McJimpson, former Duarte Rotary member; Mary Lou Elliott; Ken Caresio, former city manager; and Sylvia Whitlock, who in 1987 became the world's first female Rotary president.

Seven

DUARTE HERE AND NOW

Visitors entering Duarte at Buena Vista Street might notice a sign to their left saluting the William H. Lancaster Memorial Highway. This honors a former mayor and California assemblyman who fought hard for this access route to the city. The signature towers of Advantage Ford, CarMax, and Performance Nissan underscore the expansion of retail commercial development as well as Duarte's involvement in the California "romance of transportation." These and a surge of service industries, quality restaurants, and fast-food outlets—along with the City of Hope's continual growth—undergird steady economic progress. Duarte City Council members have been kept busy opening small businesses almost, it seems, every week.

Still the continuity with the past remains, and nowhere is this more evident than in the civic highlight—the annual Duarte Salute to Route 66, held every September. The transportation theme is complemented with a commitment to culture and quality of life issues that began with the 1884 Literary Society. After 168 years since the land grant, it says a lot that Duarte's most distinctive building is the elegant 1909 schoolhouse. The Duarte Festival of Authors has for six years drawn such literary stalwarts as science fantasist Ray Bradbury and popular television and fiction writer Stephen J. Cannell. Duarte's commitment to community life is reflected by its support of Colin Powell's America's Promise youth organization. In 2000, an Alliance for Youth movement banded together city, school, service organizations, and churches to invest significantly in its young people. One result is that Duarte is one of the few cities in the San Gabriel Valley to boast its own Teen Center.

Duarte is one of the cleanest, safest communities in the San Gabriel Valley, hosting 13 parks and sports fields, a $1-million senior center, a 500-seat performing arts center, and an award-winning fitness center that draws participants from as far away as Pasadena and Beaumont. The city's 50th anniversary of incorporation in 2007 completed a most satisfying historical cycle. There are few Duarteans, however, who do not feel that the best is yet to come.

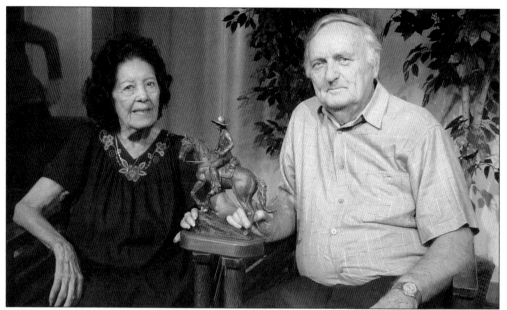

Victoria Duarte Cordova, great-great-granddaughter of Andres Duarte, met with Glendora sculptor Richard Myer in the Duarte Historical Museum in 2004 to discuss what theme—soldier or rancher—should be chosen for the proposed bronze equestrian statue of her forbear. Here they are being interviewed later in the DCTV studios. "Vicki" chose the rancher. Myer, who specializes in Western motifs, then developed the models, and finally the 12-foot-high statue was installed in 2007. (Courtesy Levon Yotnakhparian.)

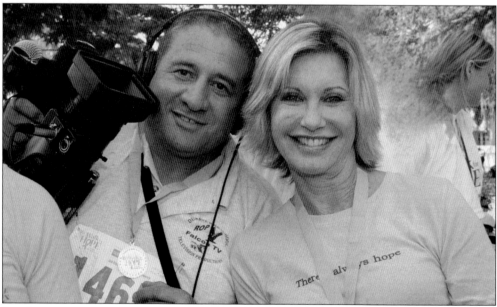

Popular entertainer and cancer survivor Olivia Newton-John poses with DCTV-Cable 55's station manager, Levon Yotnakhparian, at the annual City of Hope "Walk for Hope" in October 2006. Every year, the City of Hope sponsors a 5K Leisure Walk designed to raise awareness and raise funds for breast cancer research. This is part of a national, family-oriented, noncompetitive event that attracts some 9,000 participants every year. (Courtesy Levon Yotnakhparian.)

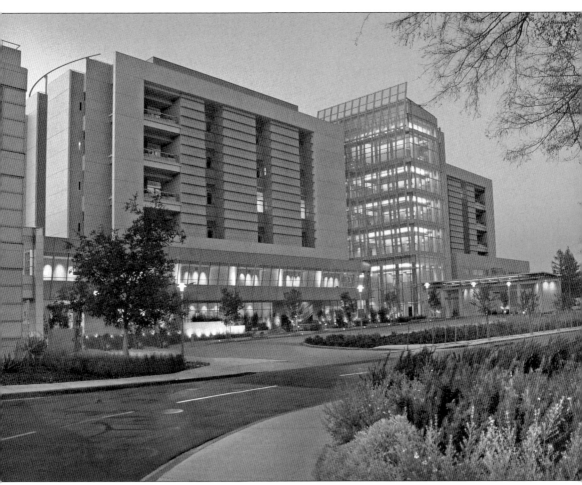

In 1914, when City of Hope first began treating tuberculosis patients, it consisted of 10 acres and a few buildings. Today City of Hope is a leader in the fight to conquer cancer, diabetes, HIV/AIDS, and other life-threatening diseases. The park-like campus encompasses 100 acres of research and medical facilities, including Helford Clinical Research Hospital, which opened in 2005. (Courtesy City of Hope Archives.)

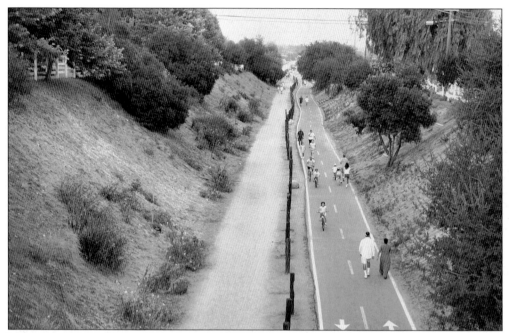

The 1.6-mile-long Duarte Multipurpose Trail was completed in 1975, and its almost constant use by walkers, joggers, and families with strollers accentuates Duarte's reputation as the City of Health. The old Oak Avenue Bridge spanning the trail recalls the days of the Pacific Electric Railway, whose upright ties still demarcate the route. (Courtesy Levon Yotnakhparian.)

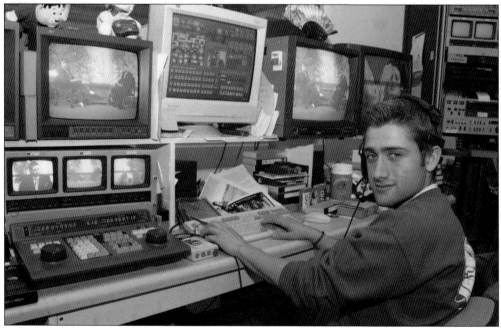

DCTV is Duarte's own public-access cable television program operating under the sponsorship of Charter Communications since 1988. Volunteer cameraman Jose Reyes of Duarte High School's Regional Occupational Program helps tape an episode of the series *Chamber Spotlight*, which profiles Duarte Chamber of Commerce member businesses. (Courtesy Levon Yotnakhparian.)

Duarte was home to Rose Parade float-building from 1995 to 2007. Floats were constructed both indoors in this industrial building located along the Santa Fe tracks at Buena Vista and in a steel-framed shelter on Buena Vista Street south of the Pavilion. Local organizations hosted the public, which visited in large numbers to view the work on the floats. The sales of souvenirs and food to visitors helped to support local nonprofit organizations. (Courtesy Susan Earle.)

Award-winning author Ray Bradbury signs copies of his books at the 2007 Duarte Festival of Authors, one of his many speaking appearances in Duarte. His motivational talks offer encouragement to budding writers. The annual festival, presented by Friends of the Duarte Library, began in 2003 and has been growing in scope and popularity presenting dozens of authors each year. (Courtesy Friends of the Duarte Library.)

Duarte City Council members Phil Reyes (left) and Lois Gaston (right) welcome congresswomen, sisters, and authors of *Dream in Color* Loretta Sanchez (center, left) and Linda Sanchez (center, right) to the Duarte Festival of Authors on October 4, 2008. The Sanchez sisters are the first sisters to serve in the U.S. House of Representatives. (Courtesy Levon Yotnakhparian.)

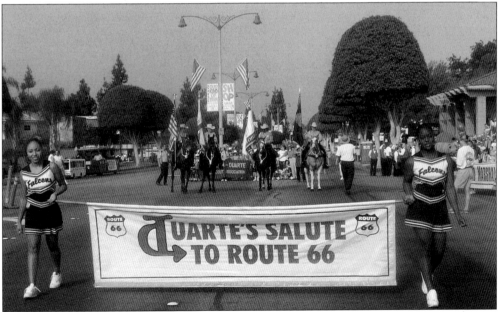

Forward march! Two students from Duarte High School exhibit a banner helping to kick off the annual Duarte's Salute to Route 66 Parade in 2005 along the city's historic stretch of Route 66, today known as Huntington Drive. The 2008 parade drew eight marching bands from across Southern California, along with antique cars, equestrian groups, and hundreds of participants from the community. (Courtesy Mary Barrow.)

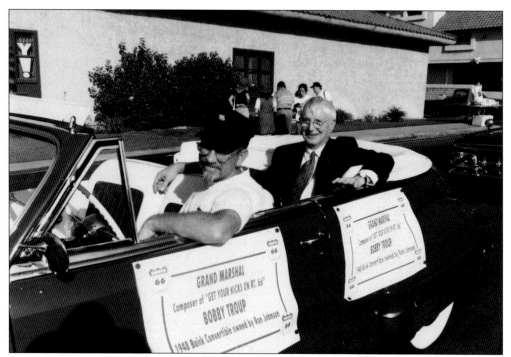

Duarte's Salute to Route 66 Parade has become a civic tradition. Each parade has a celebrity grand marshal. Equestrians, marching groups, local organizations, and bands participate. The parade concludes with an antique auto show in Royal Oaks Park. Bobby Troup (shown here), composer of the 1946 hit "Get Your Kicks on Route 66," was grand marshal of the first parade in 1996. The event celebrated the 70th anniversary of Route 66, once known as "America's Highway." (Courtesy Alan Heller.)

Martin Milner, posing in a 1962 Chevy Corvette Stingray, enthusiastically accepted an invitation to appear as parade grand marshal for the city of Duarte's 2001 Duarte Route 66 Parade and Car Show. Milner also played Officer Pete Malloy in the television series *Adam-12* (1968–1975) created by his former associate Jack Webb of *Dragnet* fame, in which Milner occasionally appeared. (Courtesy Mary Barrow.)

Riding the bull is not remotely dangerous for this skilled caballero at the 2005 Route 66 parade. He powerfully recalls the city's beginnings as the rancho that it was. This showman was joined on that day by 95 other entries. Many of them were cowgirls on Arabians from the C Star Pleasure Riders as well as actors, actresses, and stunt people from old Hollywood Westerns. (Courtesy Mary Barrow.)

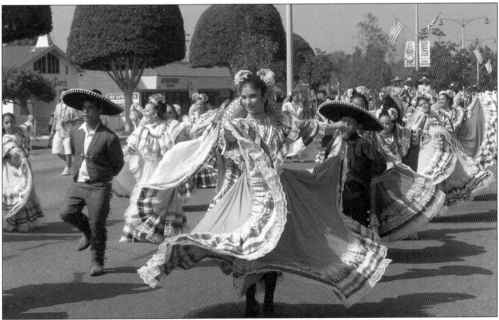

Mexico Vivo Groupo Folklorico's brightly decorated costumes and exuberant display of street dancing steal the show on Huntington Drive in 2005. It is easy to see why they are a perennial favorite at the annual parade. Composed of more than 50 colorfully costumed dancers, most of them children from Duarte, Folklorico features a full array of musicians, charros, escaramuza (the female equivalent of charros), and show horses to celebrate the history and culture of Mexico. They also eagerly participate in other community events throughout the year. (Courtesy Mary Barrow.)

Sam Shepard, the 1979 Pulitzer Prize–winning playwright of *Buried Child* and Academy Award nominee as best actor for *The Right Stuff* (1983), graduated from Duarte High School in 1961. The school yearbook lists him under the name Sam Shepard Rogers III, but he also went by the name "Steve Rogers" while he lived in Duarte from 1955 to 1963. Described as "America's most audacious living playwright," he is particularly well known for his role as test pilot Chuck Yeager in *The Right Stuff*. (Courtesy Duarte High School.)

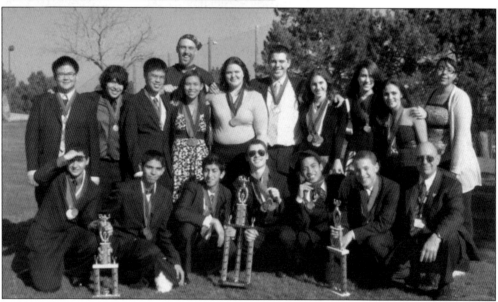

In 2008, the Academic Decathlon team from Duarte High School won the Medium-Sized School Category for both the state and national Academic Decathlon. The testing involved math, literature, economics, music, art, social, science, and essay. At the Virtual Competition held in June 2008, the 15 team members scored 33,067 points—good enough for first place in the nation in their division. Here is the team pictured at a state meet with their principal, Dr. Ed Martinez (lower right), and coach Robert Grebel. (Courtesy Levon Yotnakhparian.)

Fish Canyon Falls in the Angeles National Forest, just 3.1 miles behind Duarte, is an 80-foot, three-tiered waterfall and one of the most spectacular in the San Gabriel Mountain chain. Each year in the spring, as many as 300 hikers set out for an annual trek that takes them through abundant sycamore, bay, bigleaf maples, alders, willows, and live oak. Lush ferns and rugged, chaparral-covered canyon walls provide a surprising and unexpected treat for the eyes. Signs pointing out such landmarks as the Old Cheezer Mine have slowly eroded, but the well-maintained hiking path climbs gently upward and then slowly descends to the sparkling pool and creek at the bottom of the falls. (Courtesy Alan Heller.)

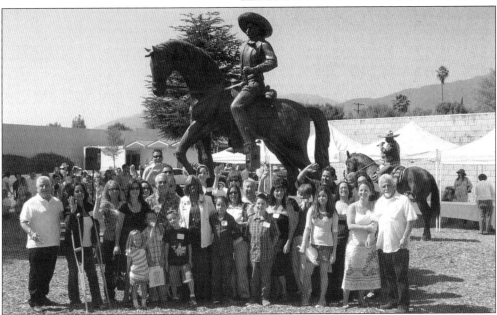

On March 31, 2007, public officials and over 30 direct descendants of Andres Duarte, shown here, met to dedicate the new bronze statue. Some of the visitors were local, but others came from as far away as Hawaii. The statue is the largest work of public art in the San Gabriel Valley. It is located on the north side of Huntington Drive, across the street from city hall in a newly completed Plaza Duarte. The plaza is intended to provide a gathering place for public events and informal use. This event reinforced the close relationship between the city of Duarte, the Rancho Azusa de Duarte, and the descendants of Andres Avelino Duarte. (Courtesy City of Duarte.)

ABOUT THE DUARTE HISTORICAL SOCIETY

The Duarte Historical Society was founded in 1951 to preserve the memory of the Duarte rancho and its occupants. Over the years, it has collected images, documents, and artifacts from residents, volunteers, visitors, and especially from those who directly, or through their ancestors or business predecessors, have occupied themselves on the Duarte rancho.

Every generation thinks it is appropriate to remake its environment. This makes the appearance of Duarte today so different from that of decades, and particularly of a century ago, that few can recognize any physical similarity between now and then. Encouraging the reuse of worthy buildings, reminding ourselves through historical markers, and providing historical perspectives to the public and public agencies are activities undertaken by the Duarte Historical Society to keep the memories alive, useful, and part of civic consciousness.

BIBLIOGRAPHY

Barrow, Mary. "KTLA's Michaela Pereira Named Grand Marshall for Duarte's 10th Annual Route 66 Parade, Sept. 17." *Duarte View*. September–October 2005: 1, 10.

Butko, Tatiana. "Tribute to Glenn Miller: Duarte to place commemorative plaque in park." *Pasadena Star News*. 2001.

Davis, Charles F. *History of Monrovia and Duarte*. Monrovia, CA: News-Post, 1938.

Duncan, Glen. *Route 66 in California*. Charleston, SC: Arcadia Publishing, 2005.

Earle, Neil. " 'Feeding on Life:' Ray Bradbury Still packs a wallop." *Duarte View*. November–December 2007: 10.

Fritz, Christian G. *Federal Justice in California—The Court of Ogden Hoffman*. Lincoln and London: University of Nebraska Press, 1991.

Harlow, Dan. "Celebrating 79 Years of Route 66." *Duarte View*: Official Route 66 Parade Program. September 17, 2005: 2–3.

Heller, Claudia. "City pays tribute to former mayor and his vision." *Star Community News*. March 7, 2004: 2.

Maddaus, Gene. "Fish Canyon Lures Hikers." *Pasadena Star-News*. Sunday, April 17, 2005.

Moore, R. Aloysia, and Bernice Watson. *On the Duarte*. Duarte, CA: City of Duarte, 1976.

Northrop, Marie E. *Spanish-Mexican Families of Early California, 1769–1850*. Vols. 1, 2, and 3, 1st ed. New Orleans, LA: Polyanthos, 1976; Vol. 2, Burbank, CA : Southern California Genealogical Society, 1984; Vol. 3, Los Pobladores de la Reina de Los Angeles.

Shrode, Ida May. *The Sequent Occupance of the Rancho Azusa de Duarte: A segment of the Upper San Gabriel Valley of California*. Ph.D. dissertation, University of Chicago, Chicago, IL, 1948.

Wight, Jan, ed. *Celebrating 50 Years: City of Duarte, 1957–2007*. Elgin, IL: Village Profile, Inc., 2007.

ACROSS AMERICA, PEOPLE ARE DISCOVERING SOMETHING WONDERFUL. *THEIR HERITAGE.*

Arcadia Publishing is the leading local history publisher in the United States. With more than 5,000 titles in print and hundreds of new titles released every year, Arcadia has extensive specialized experience chronicling the history of communities and celebrating America's hidden stories, bringing to life the people, places, and events from the past. To discover the history of other communities across the nation, please visit:

www.arcadiapublishing.com

Customized search tools allow you to find regional history books about the town where you grew up, the cities where your friends and family live, the town where your parents met, or even that retirement spot you've been dreaming about.